ASPCA.ORG

WE ARE THEIR VOICE.®

Amazing Animals!

COLORING WITH A CAUSE

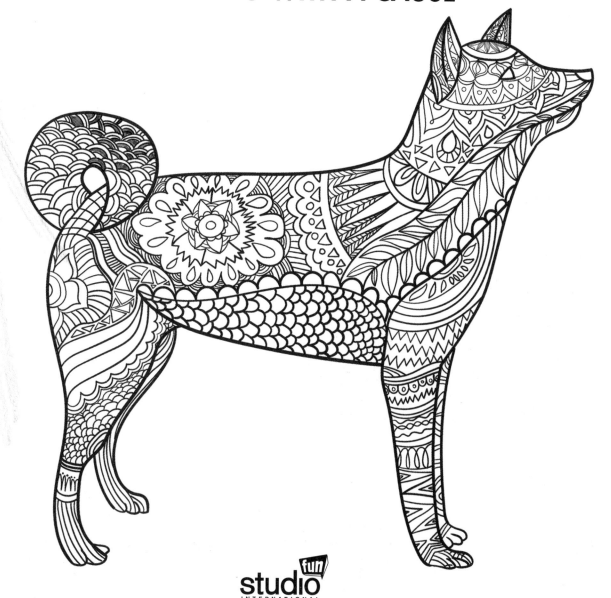

studio fun
INTERNATIONAL

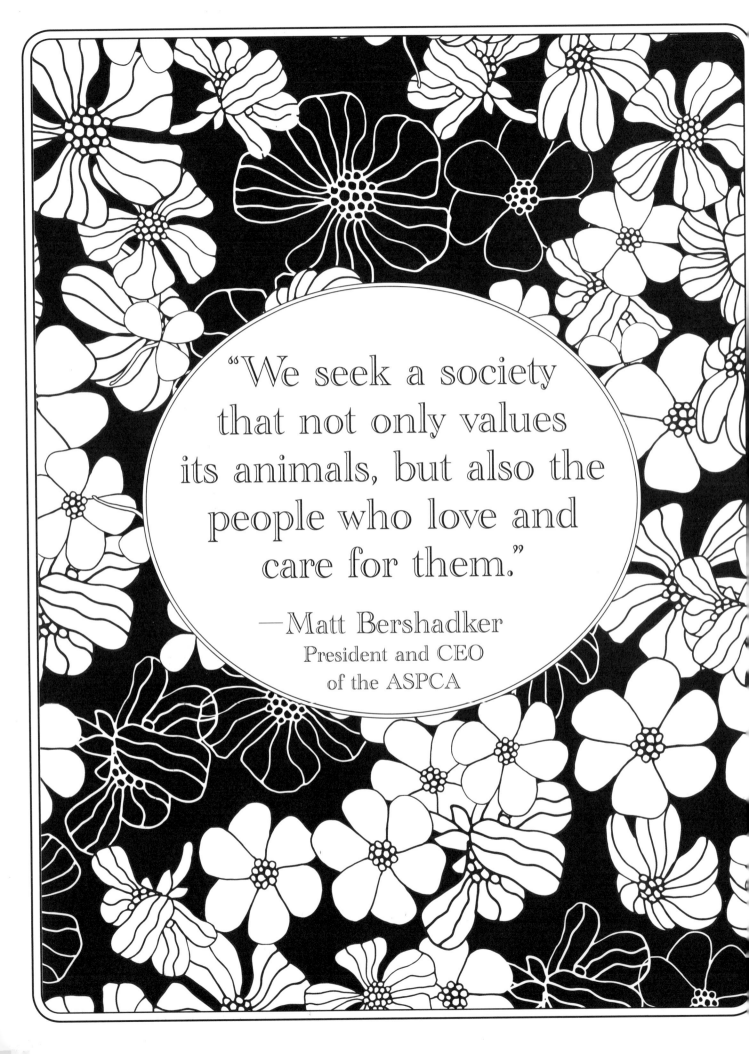

"We seek a society that not only values its animals, but also the people who love and care for them."

—Matt Bershadker
President and CEO
of the ASPCA

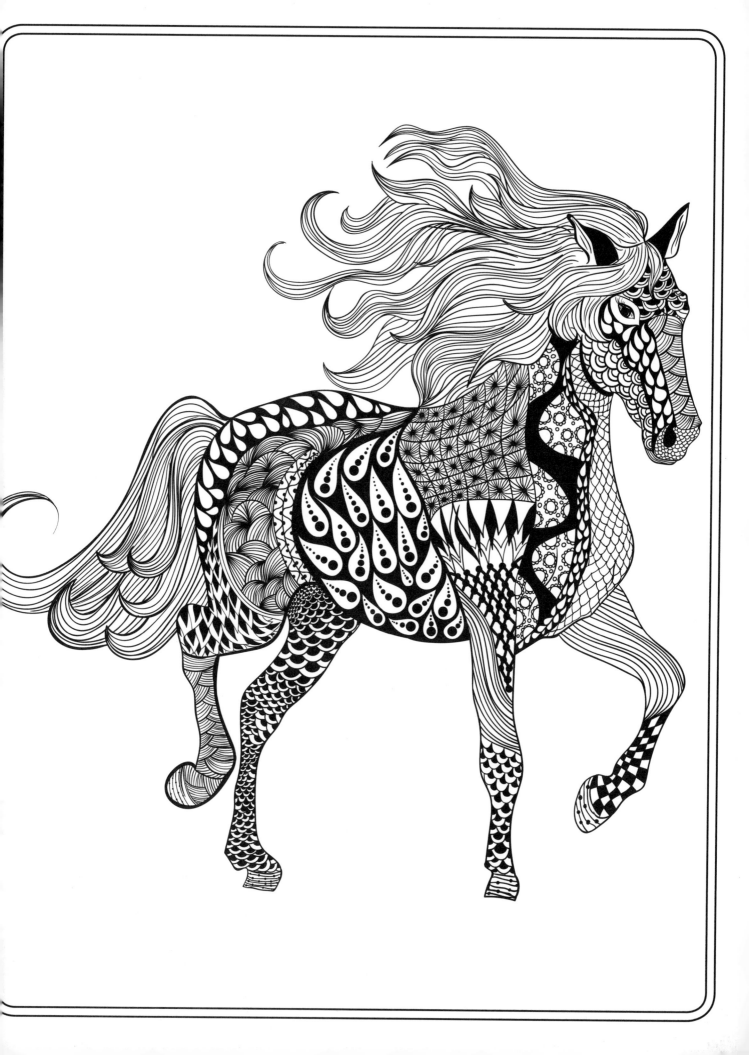

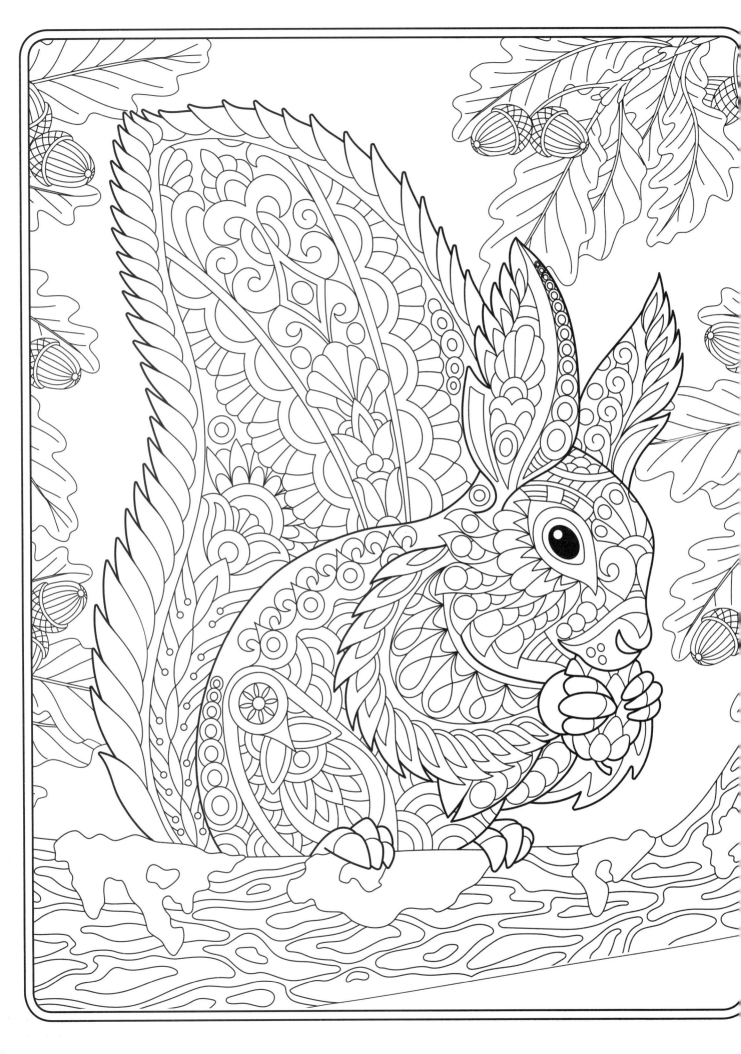

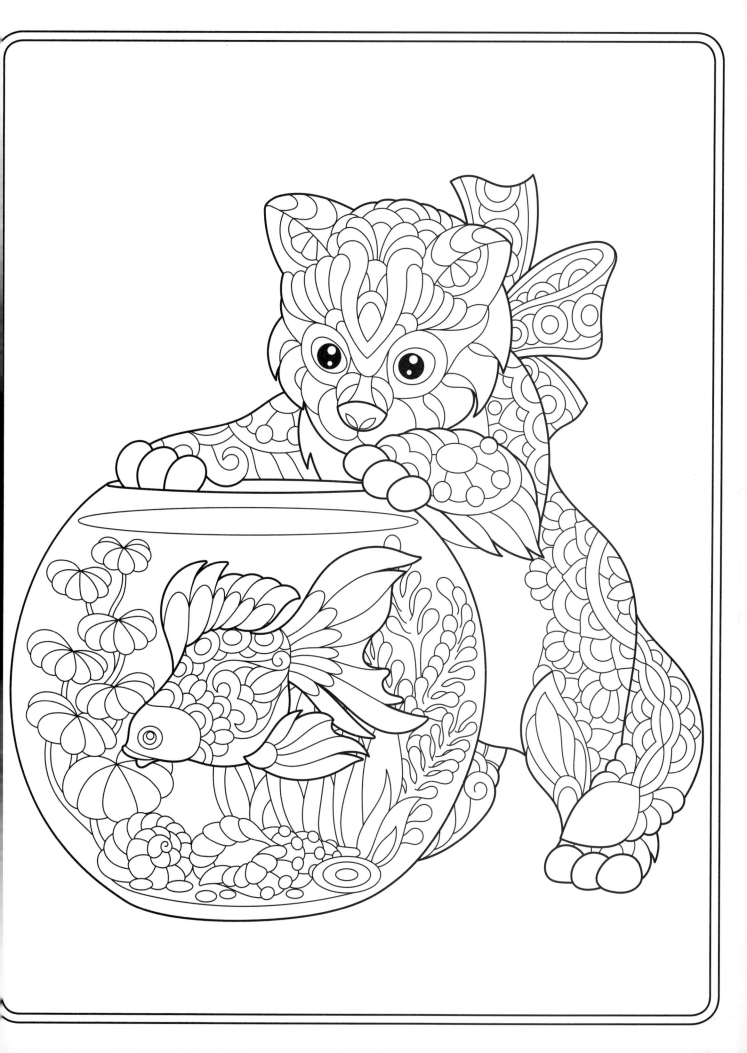

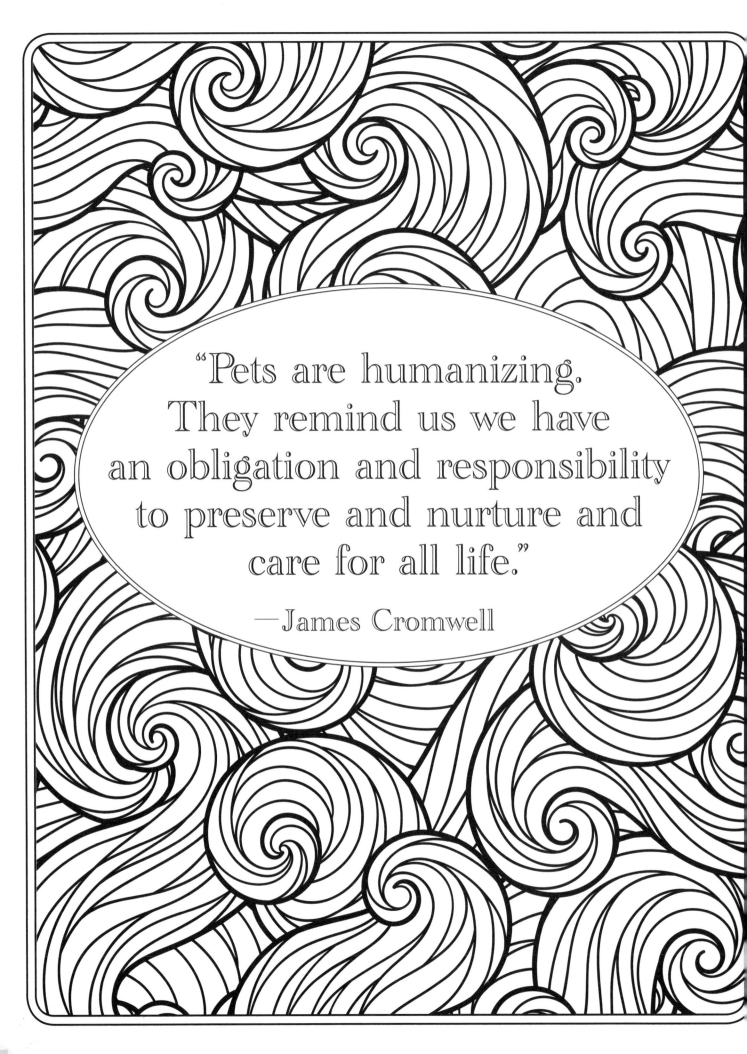

"Pets are humanizing.
They remind us we have
an obligation and responsibility
to preserve and nurture and
care for all life."

—James Cromwell

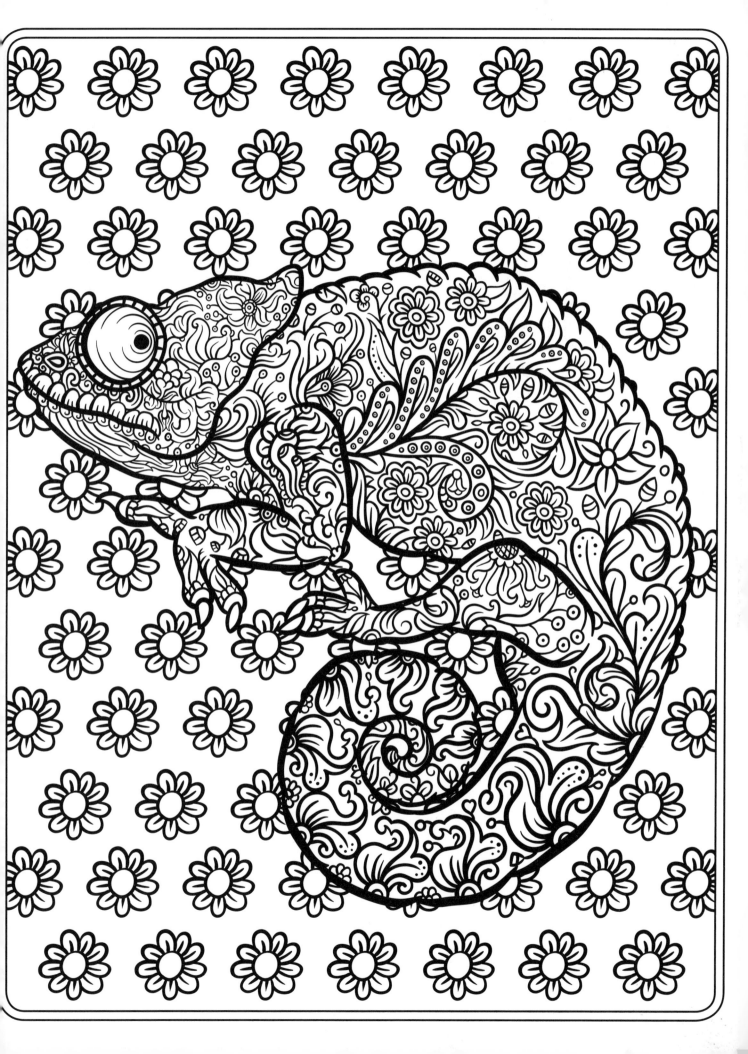

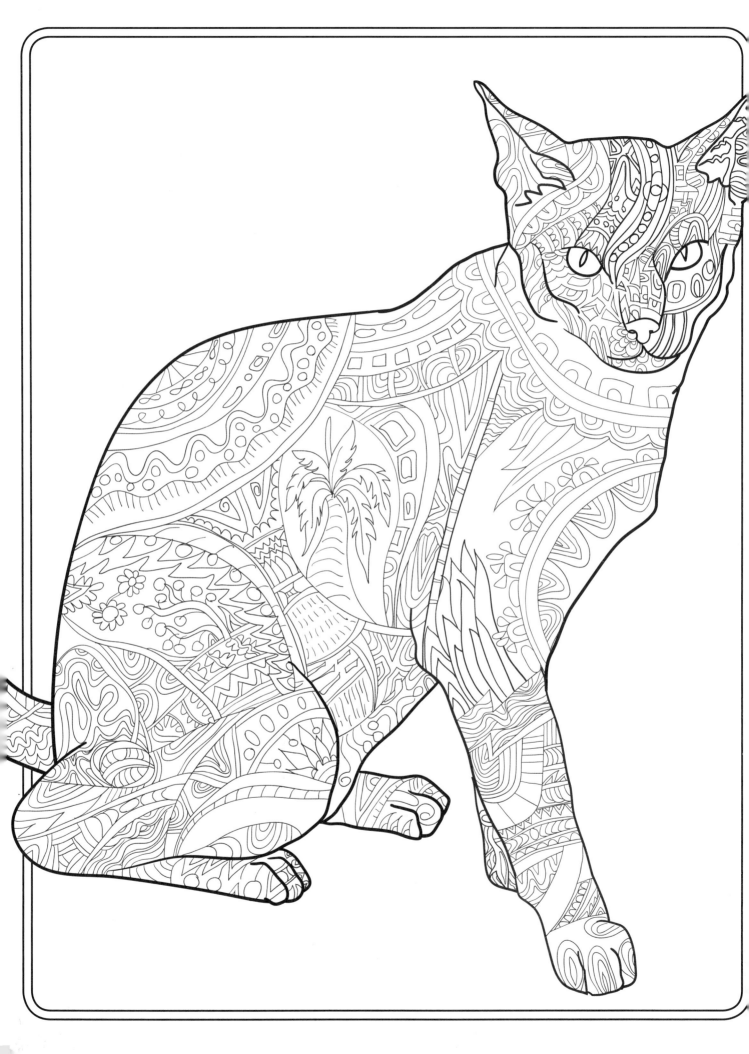

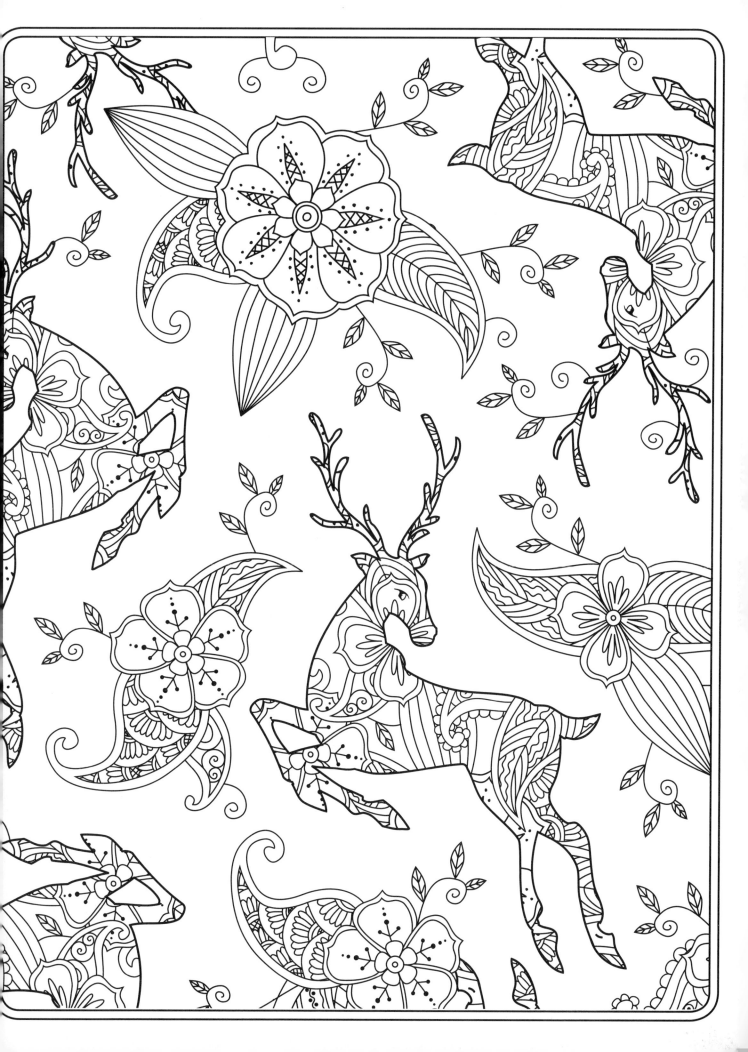

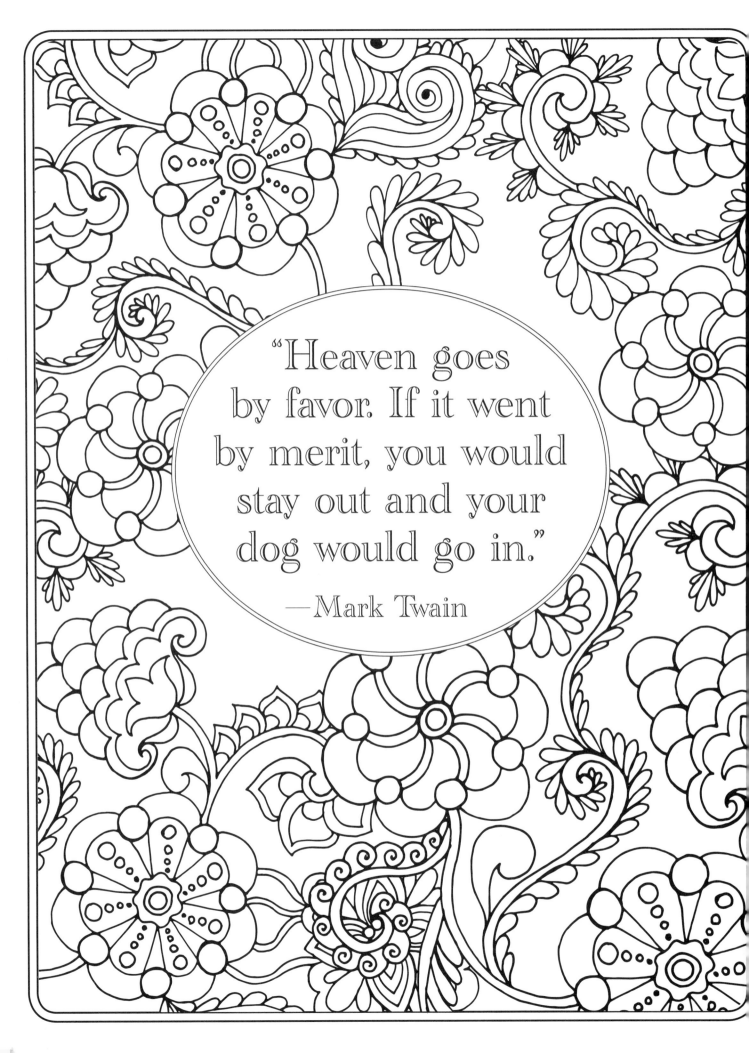

"Heaven goes by favor. If it went by merit, you would stay out and your dog would go in."

—Mark Twain

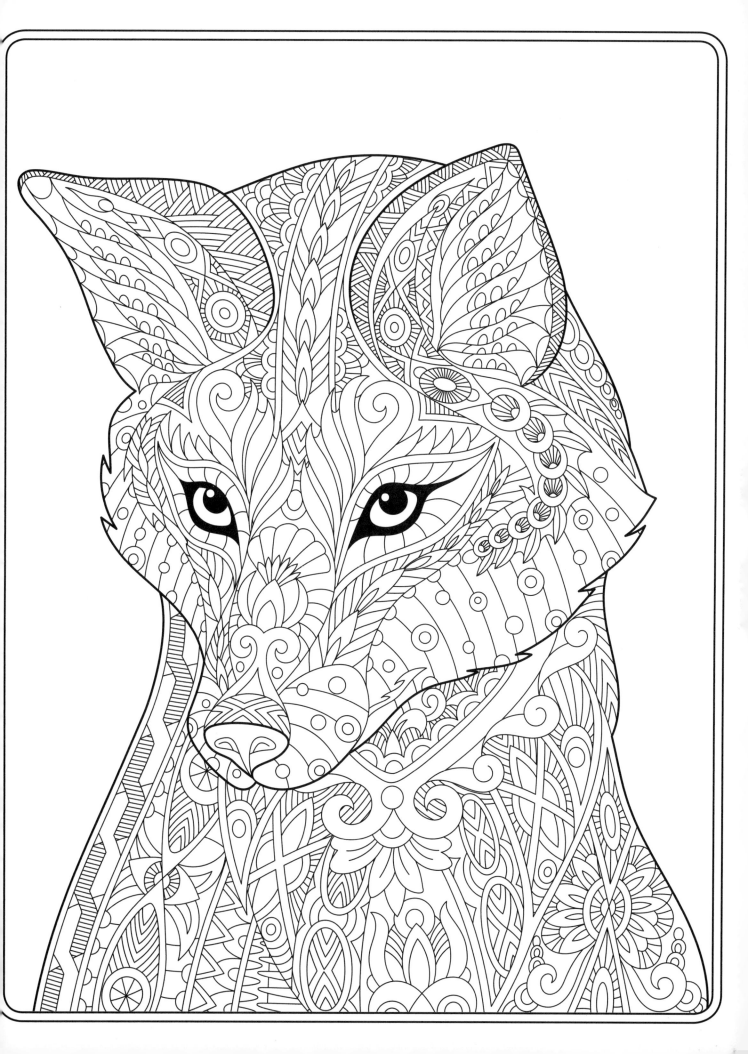

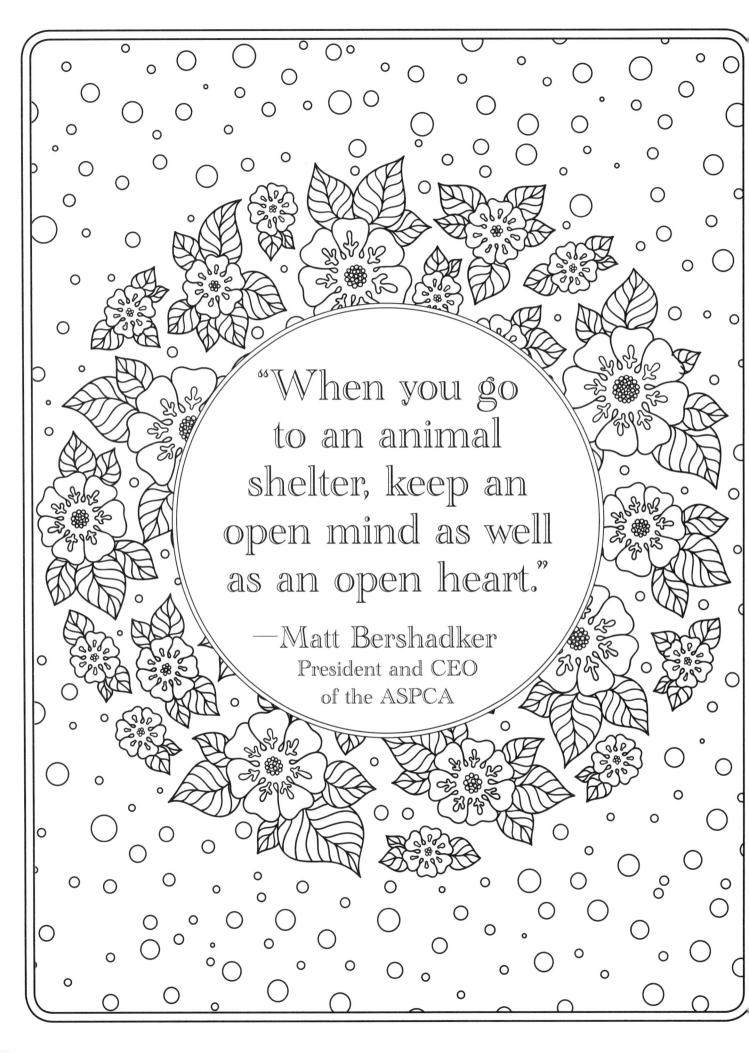

"When you go to an animal shelter, keep an open mind as well as an open heart."

—Matt Bershadker
President and CEO
of the ASPCA

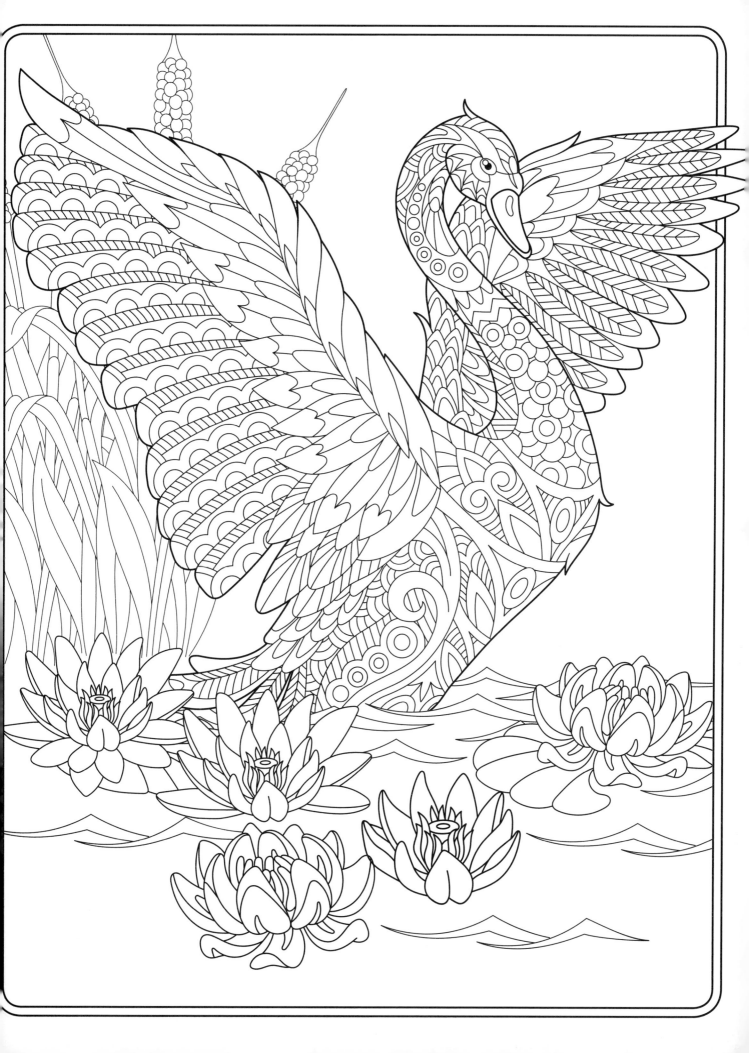

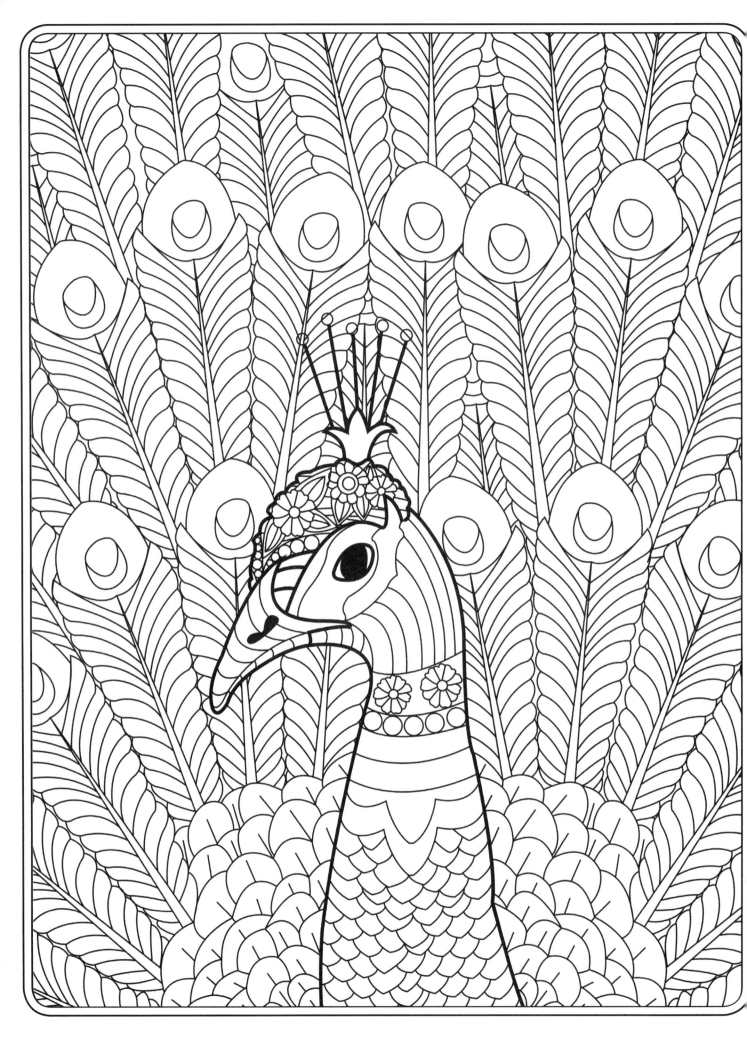

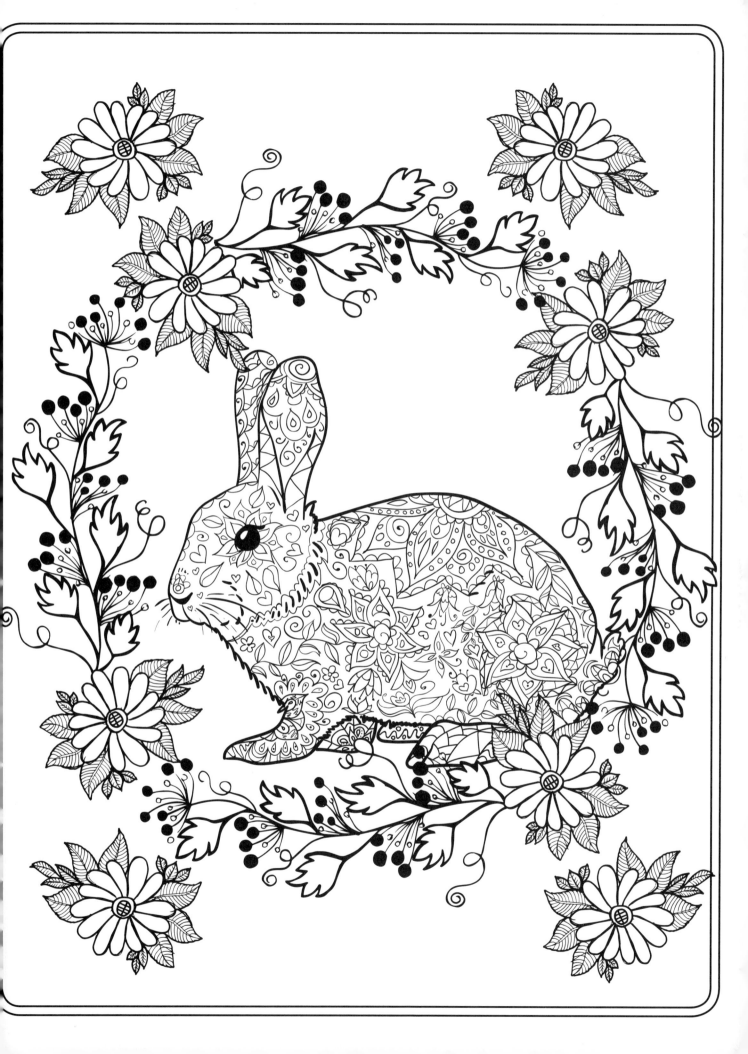

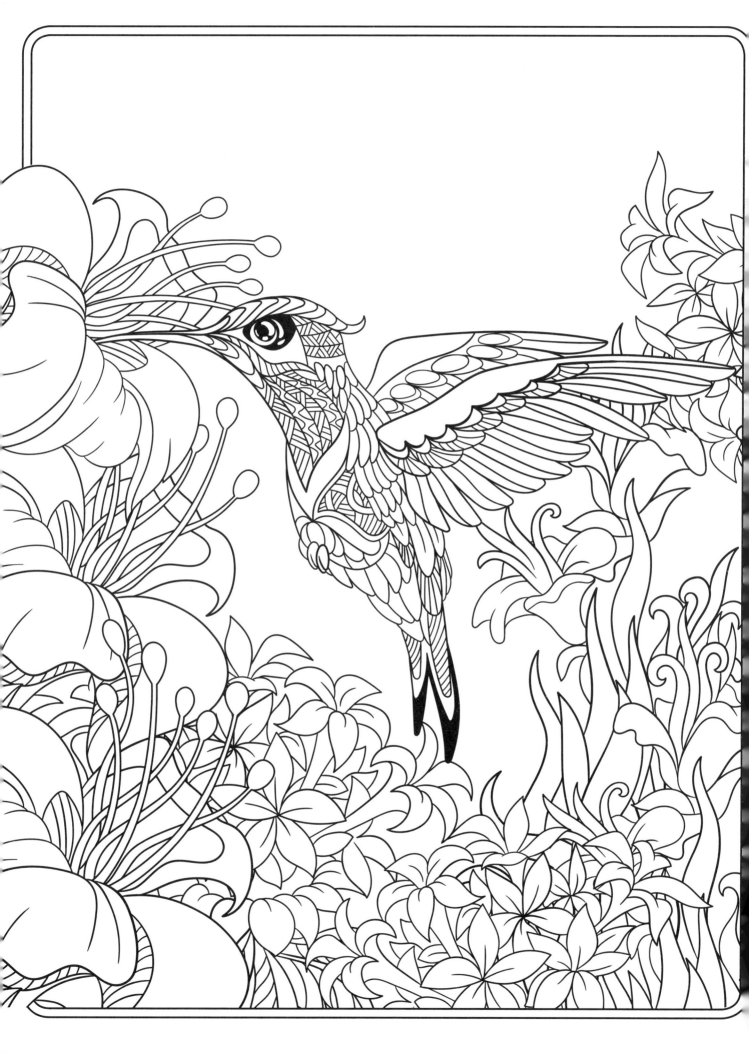

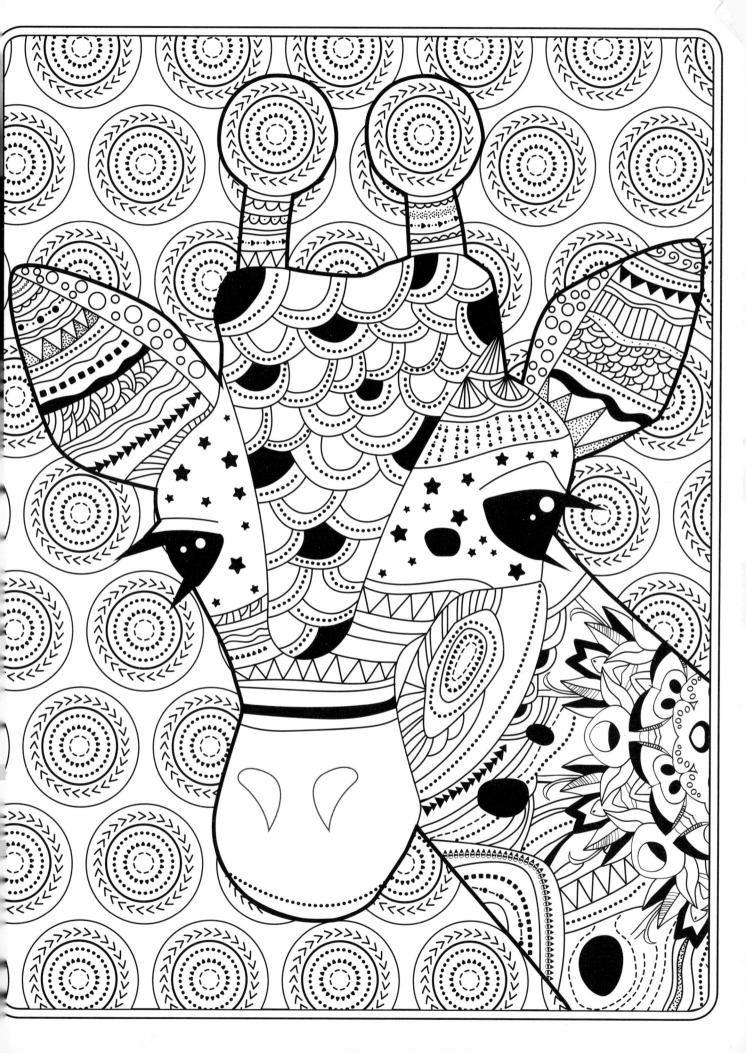

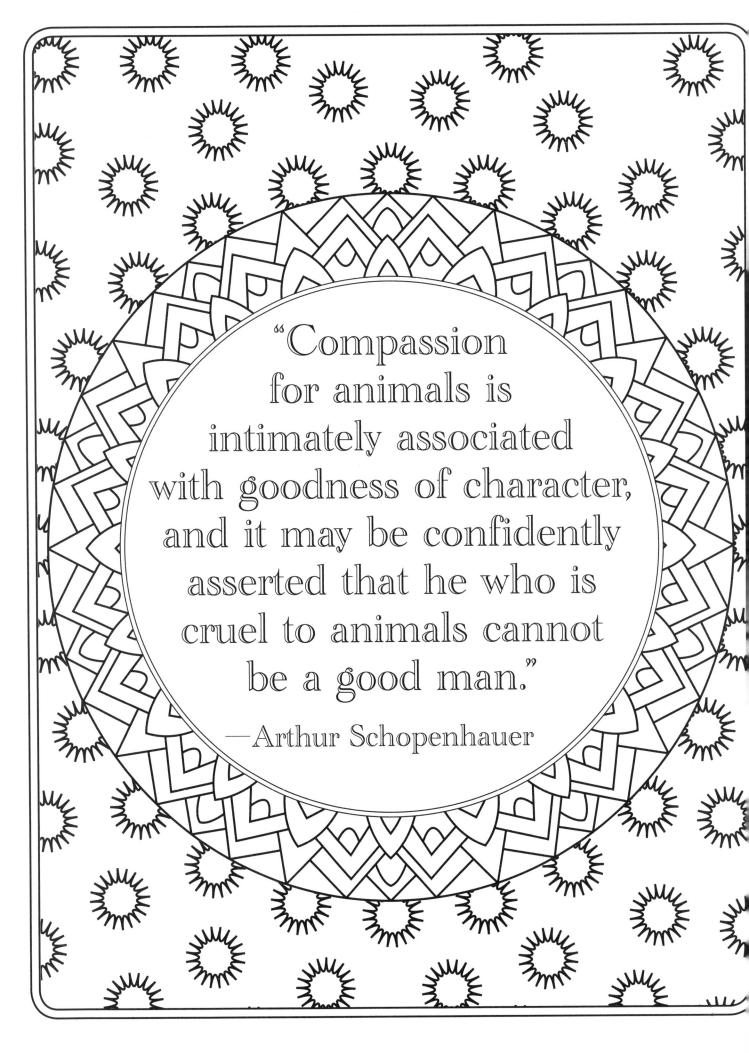

"Compassion
for animals is
intimately associated
with goodness of character,
and it may be confidently
asserted that he who is
cruel to animals cannot
be a good man."

—Arthur Schopenhauer

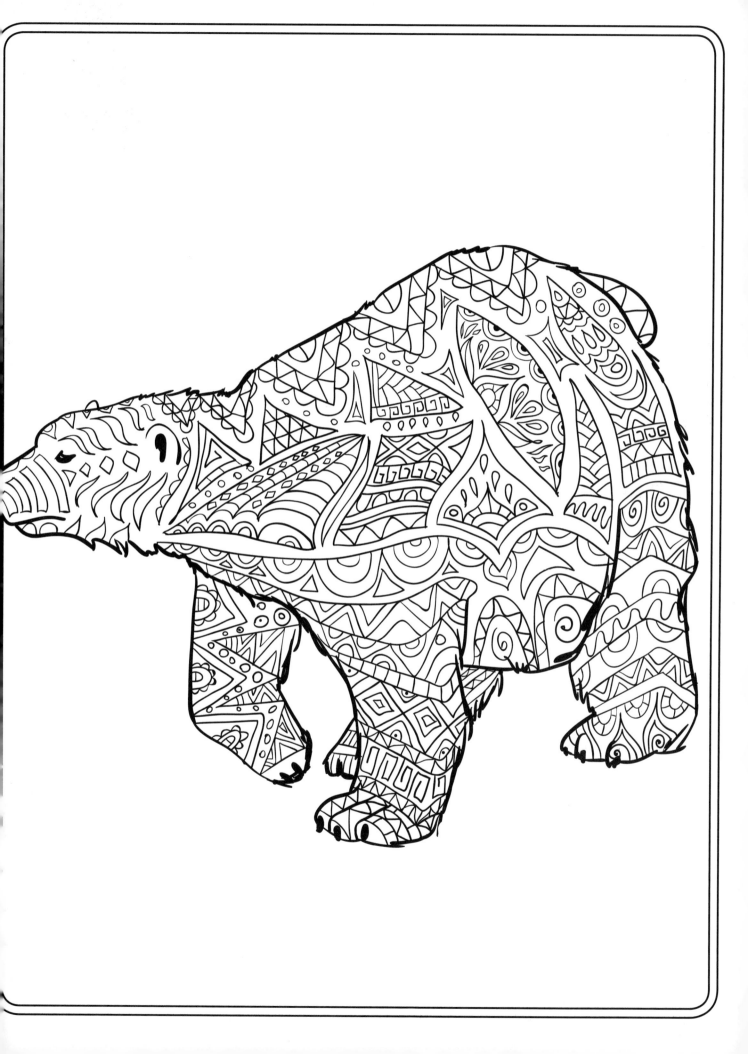

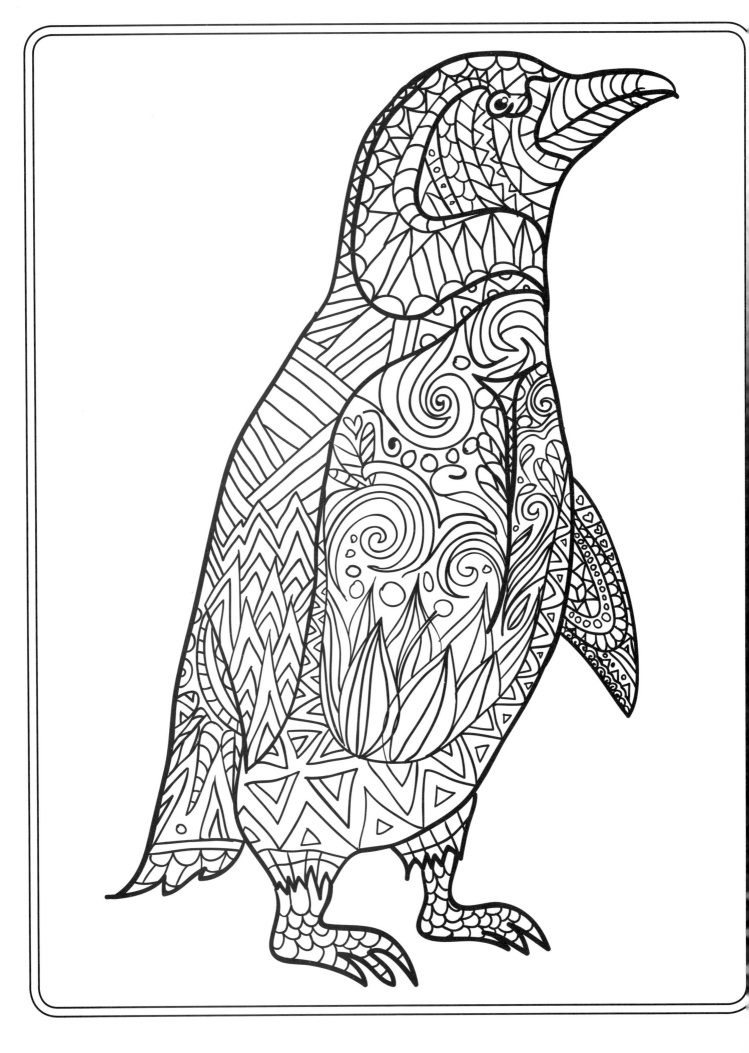

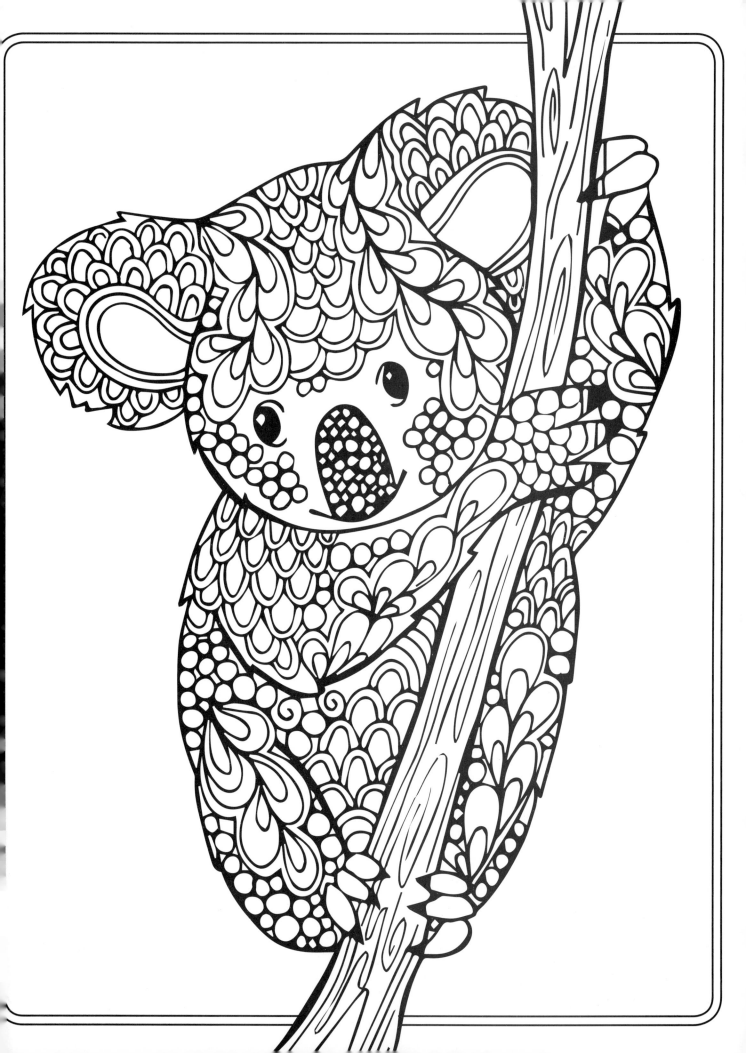

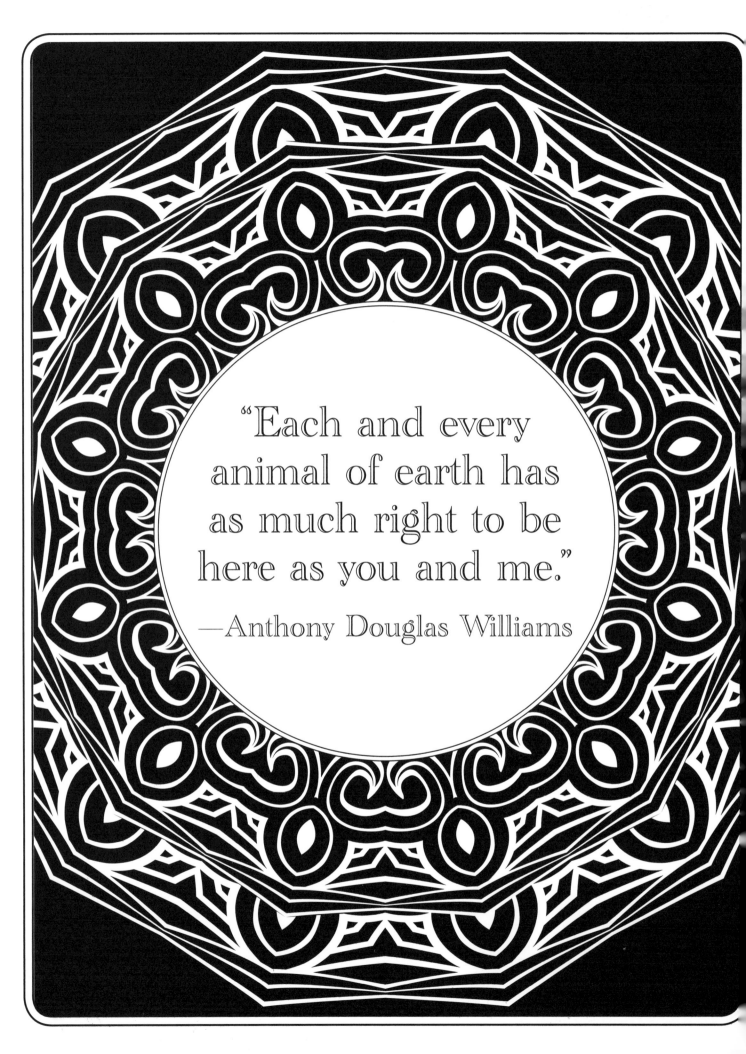

"Each and every animal of earth has as much right to be here as you and me."

—Anthony Douglas Williams

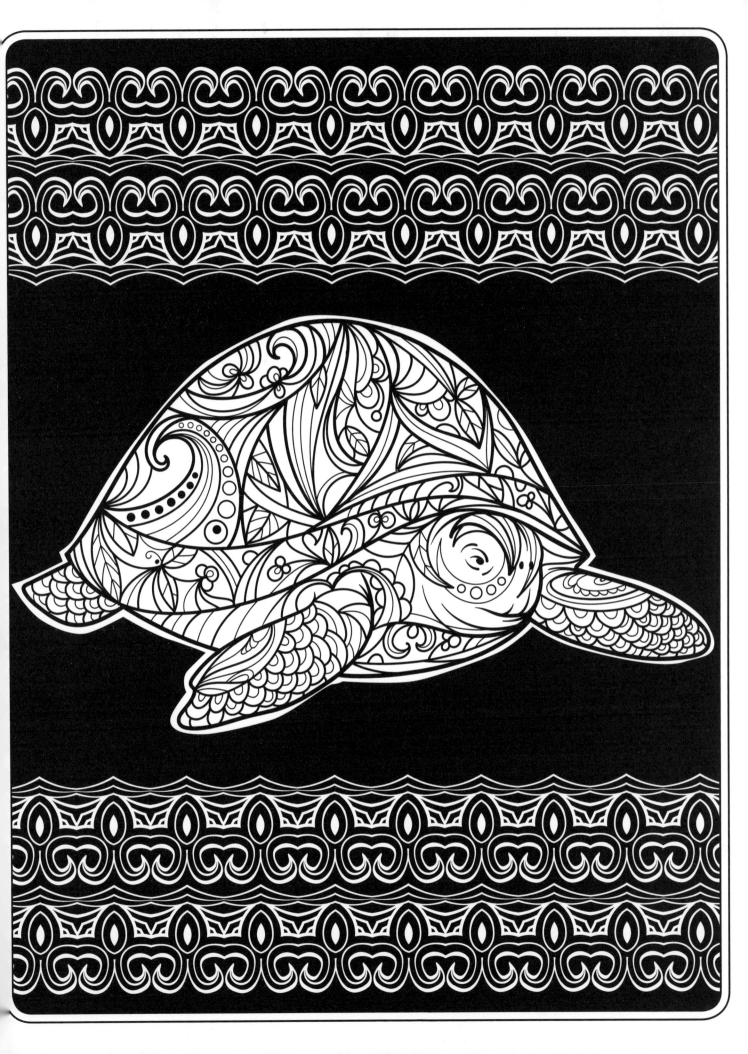

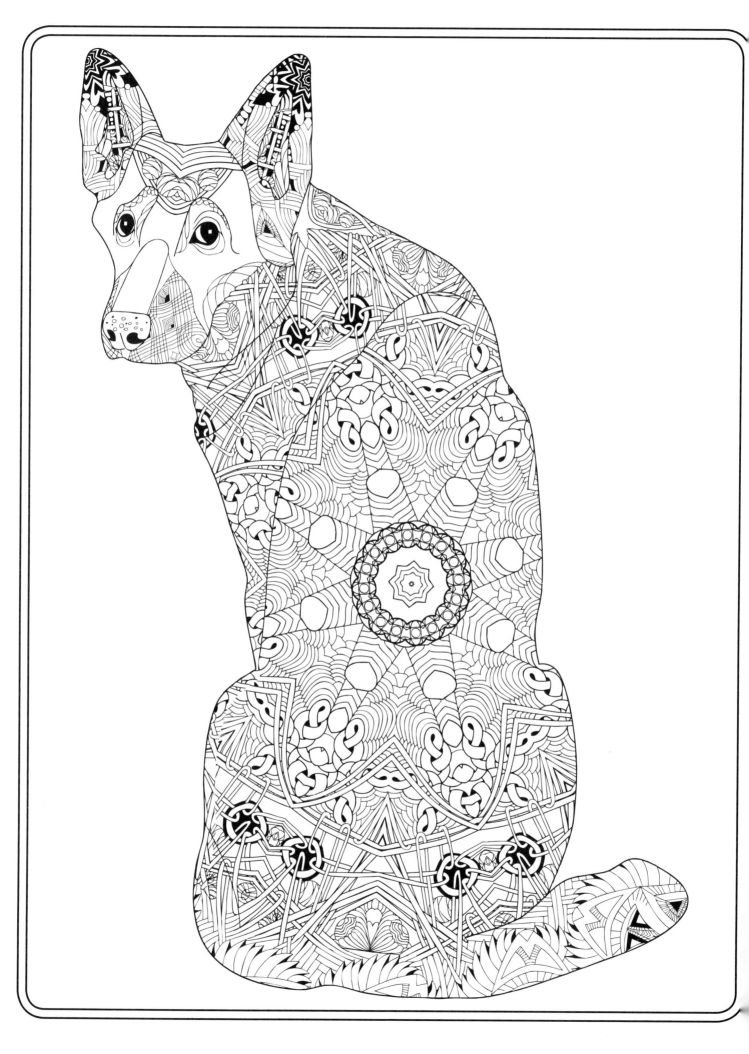

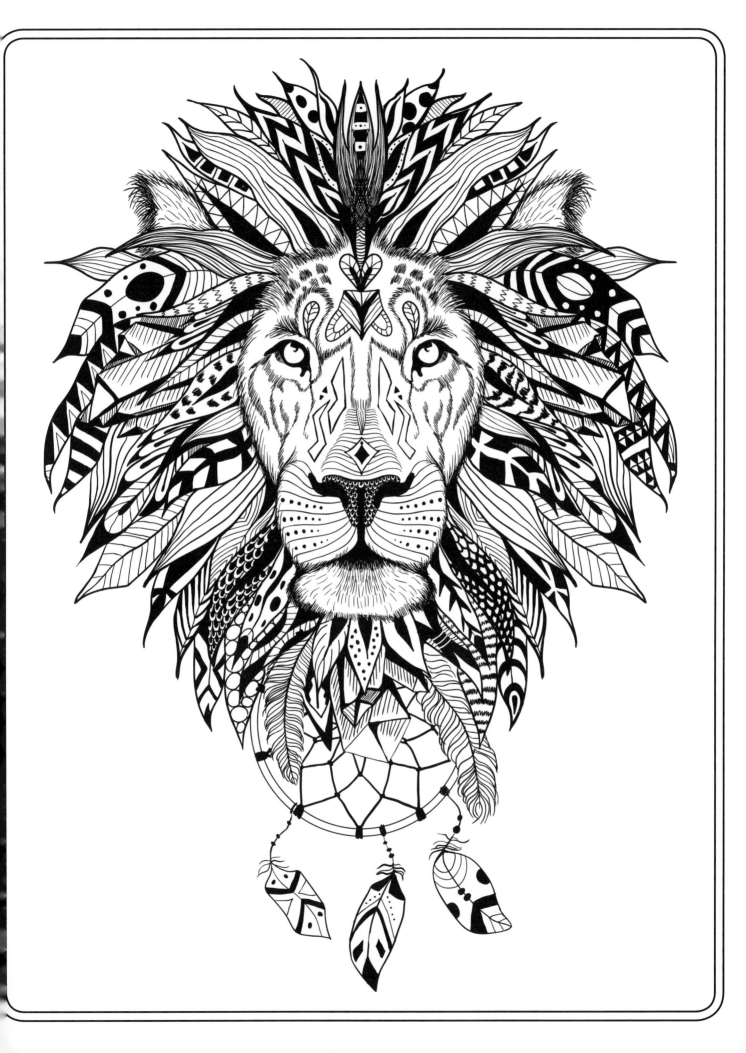

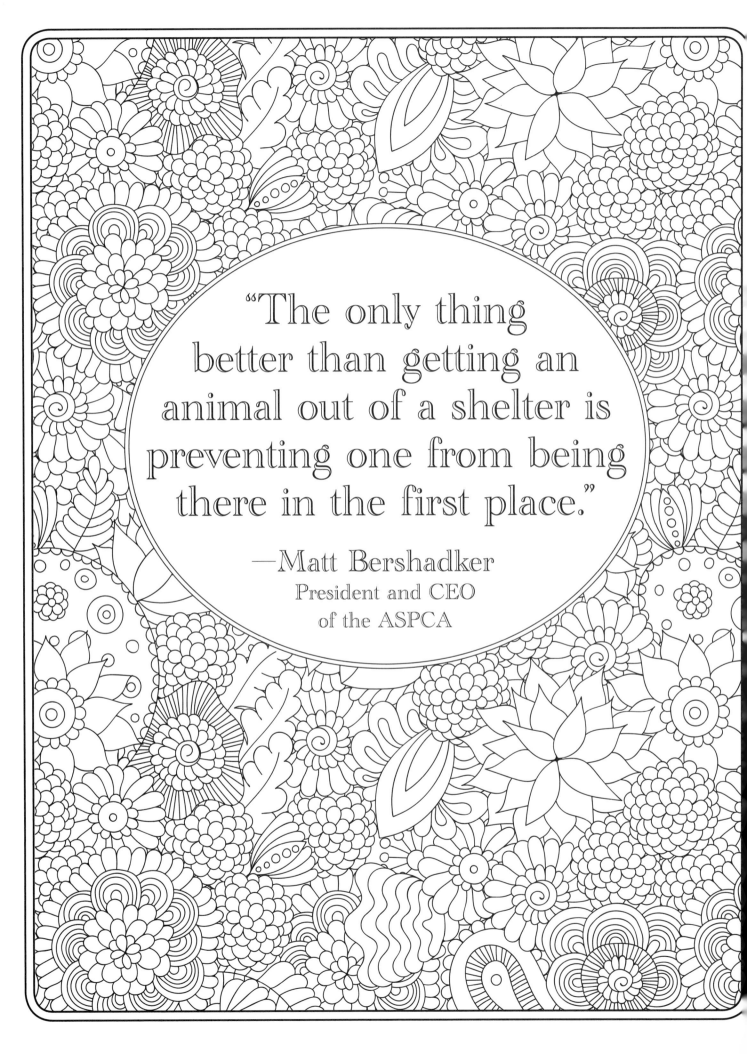

"The only thing better than getting an animal out of a shelter is preventing one from being there in the first place."

—Matt Bershadker
President and CEO
of the ASPCA

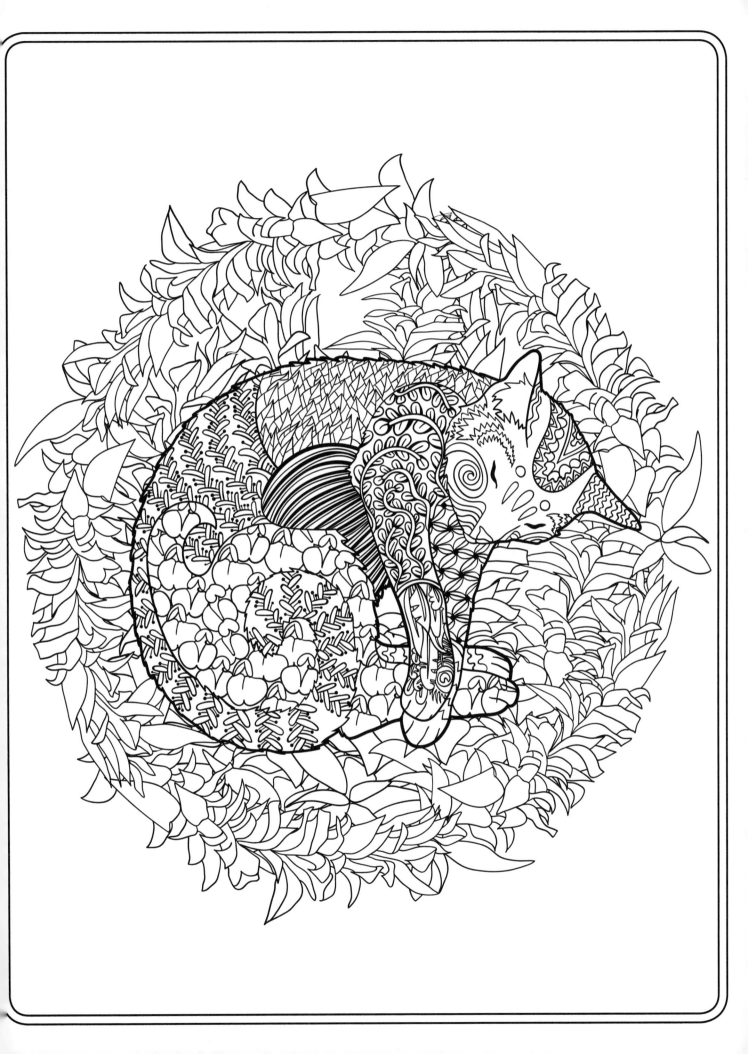

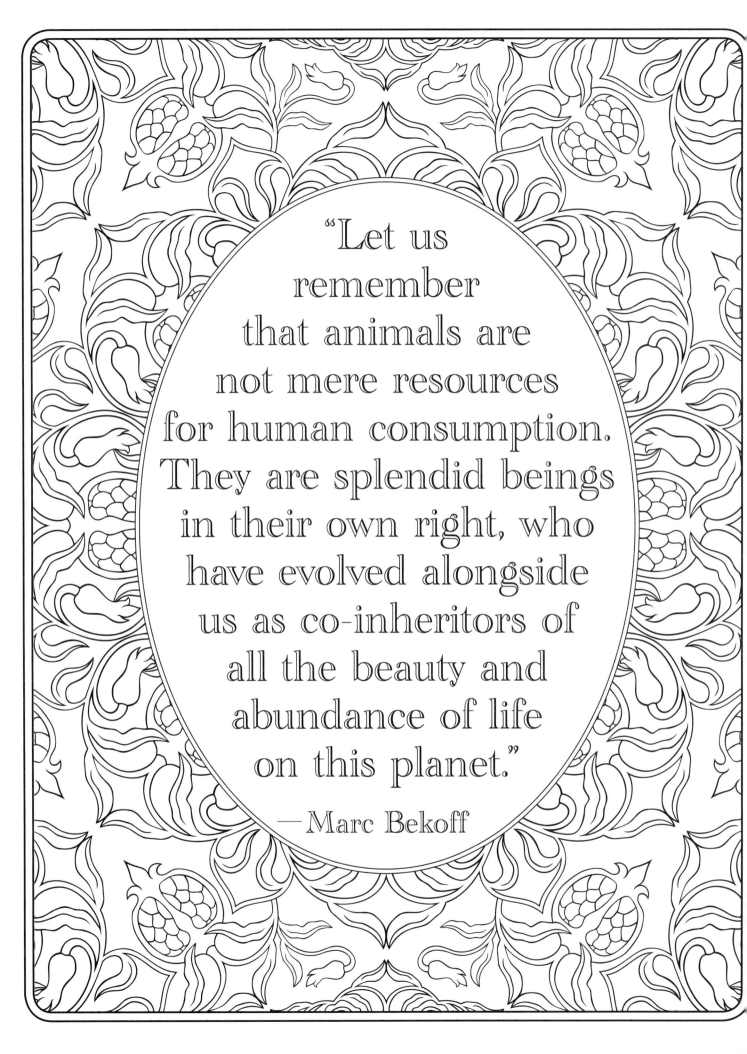

"Let us
remember
that animals are
not mere resources
for human consumption.
They are splendid beings
in their own right, who
have evolved alongside
us as co-inheritors of
all the beauty and
abundance of life
on this planet."

—Marc Bekoff

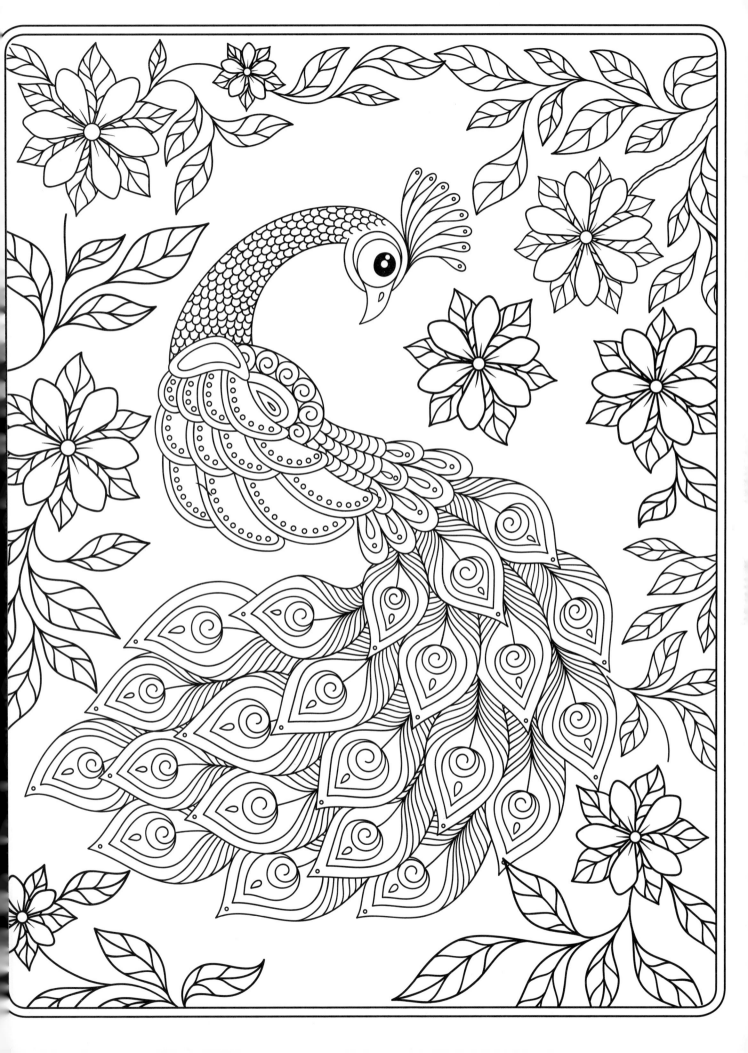

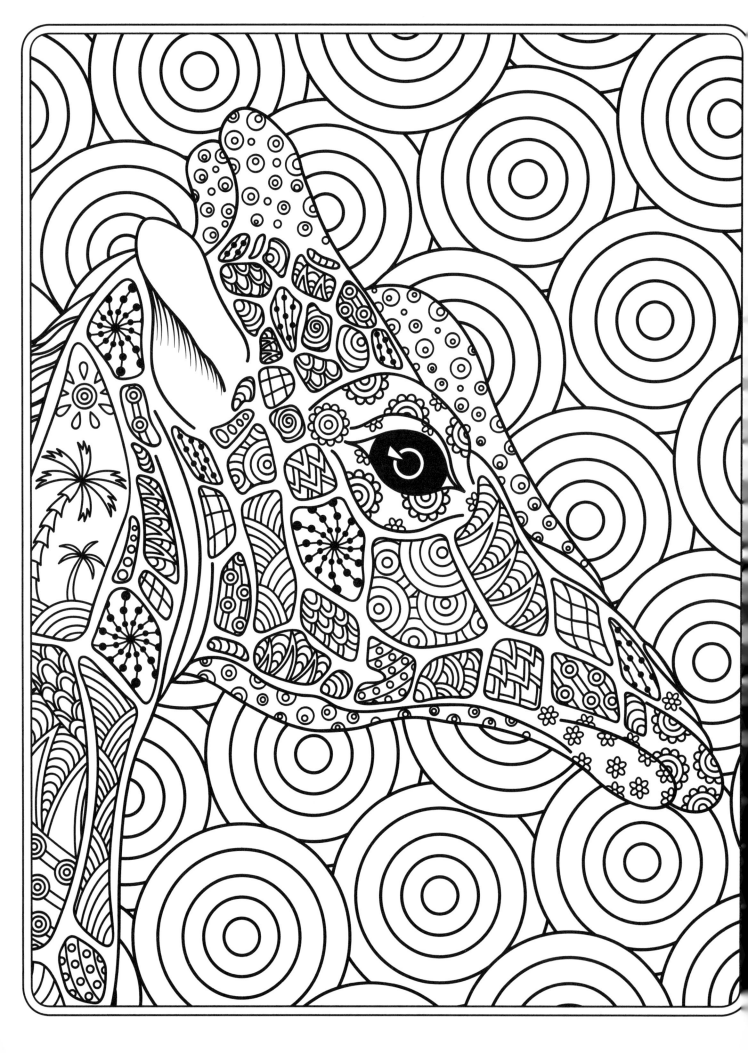

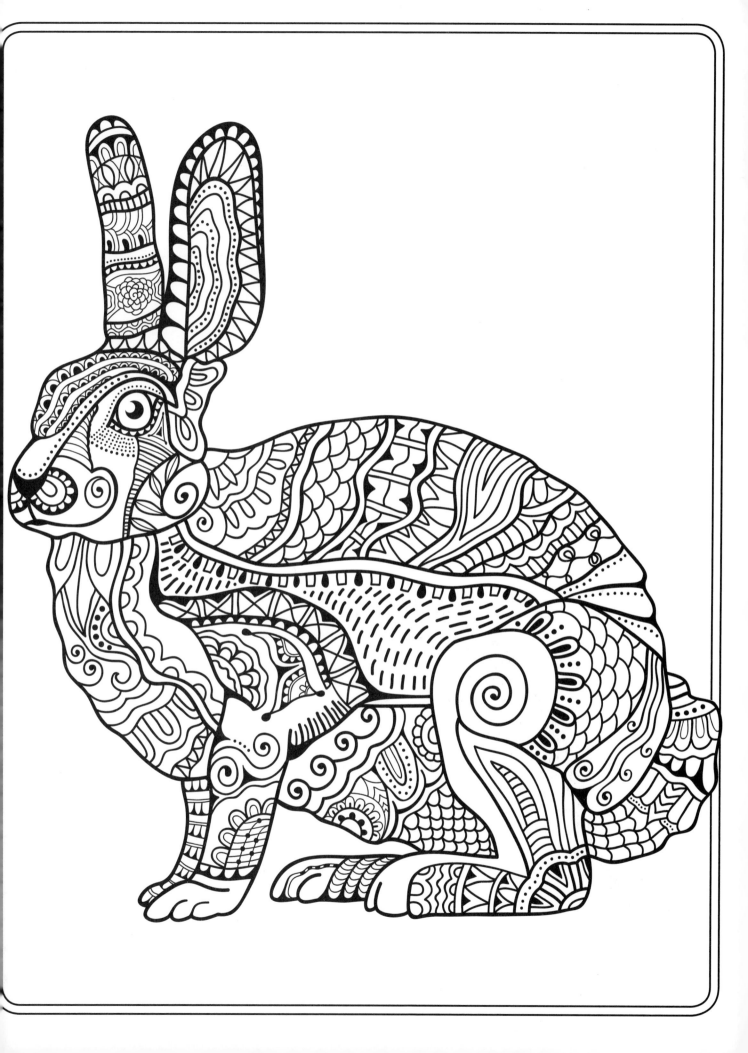

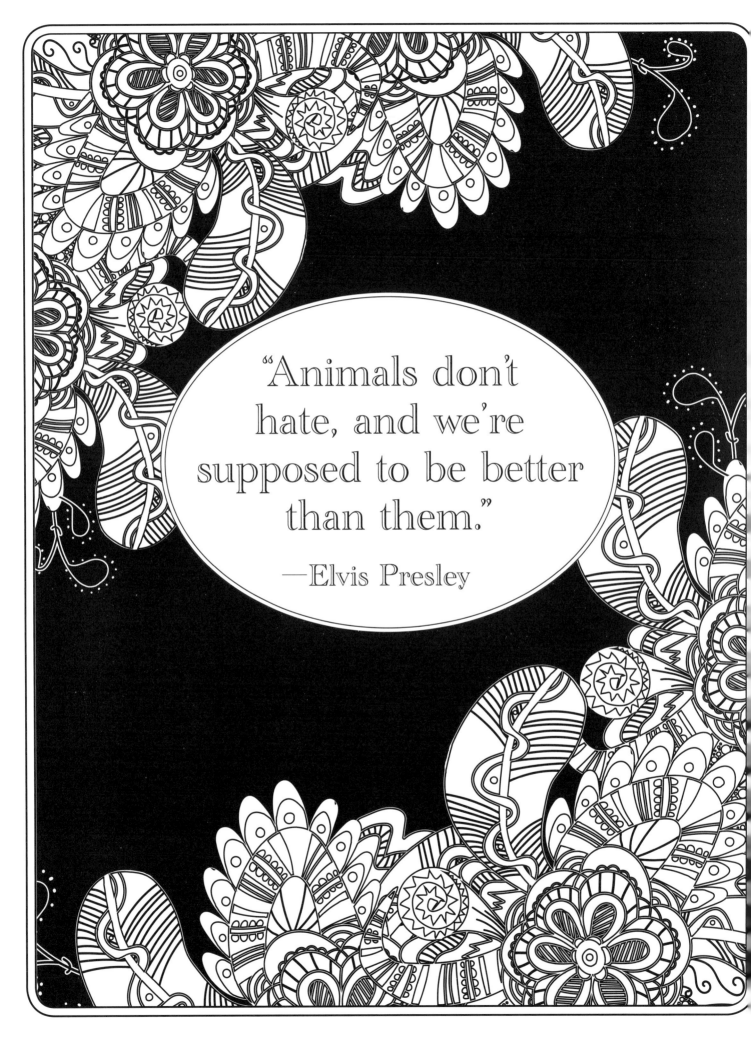

"Animals don't hate, and we're supposed to be better than them."

—Elvis Presley

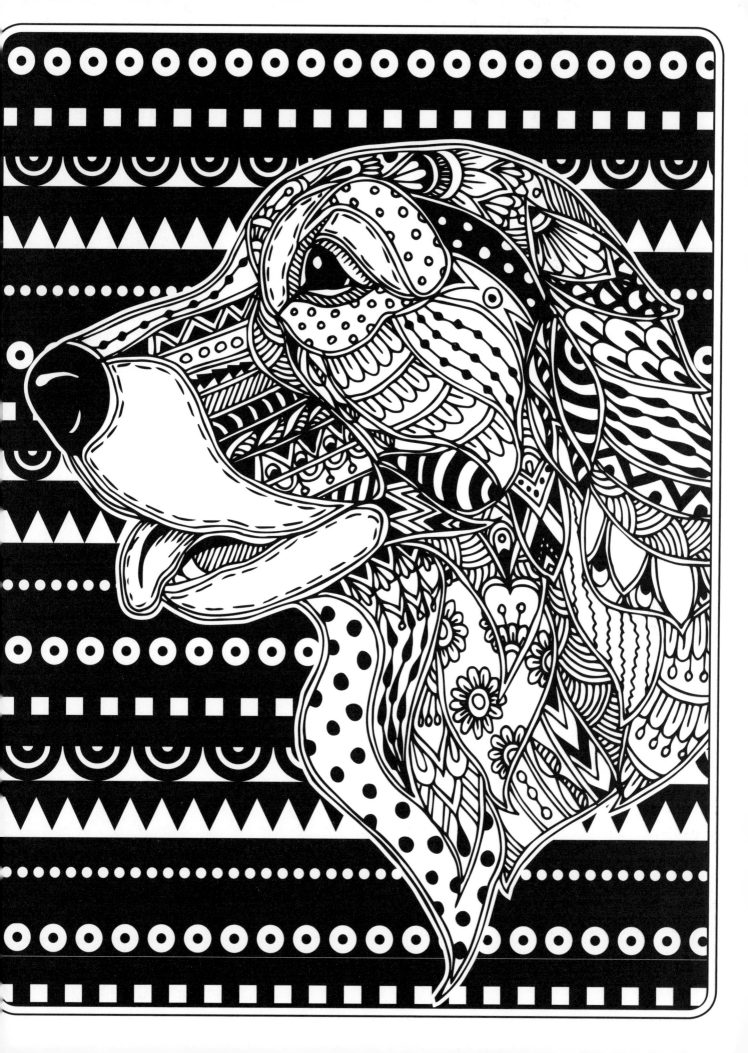

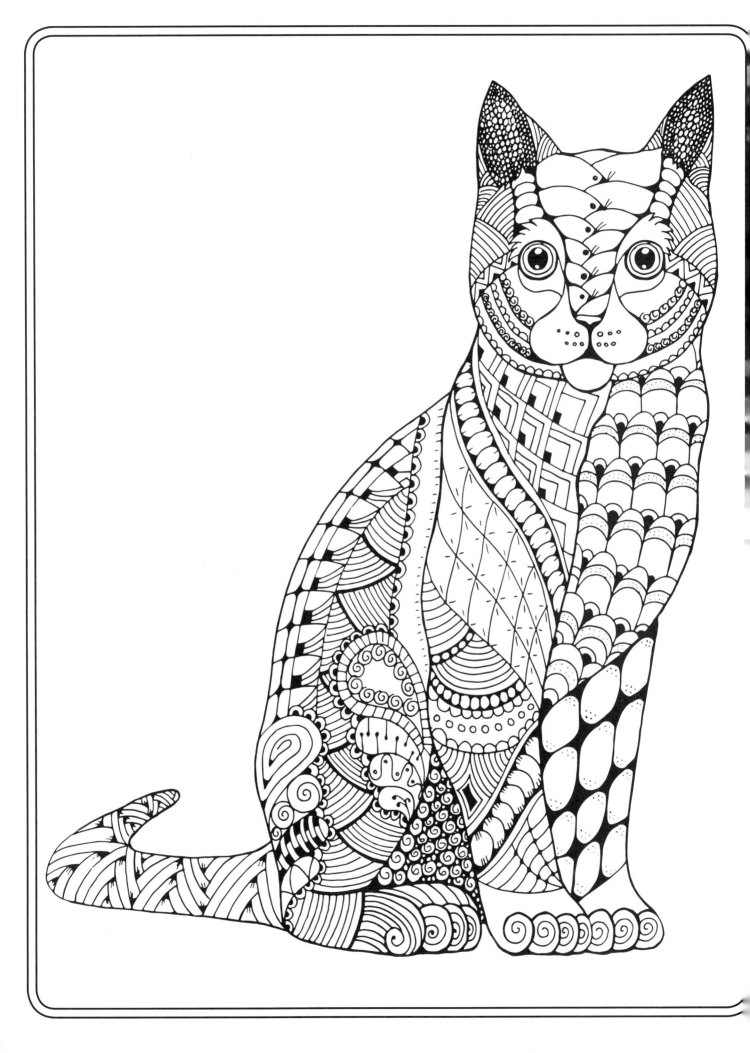

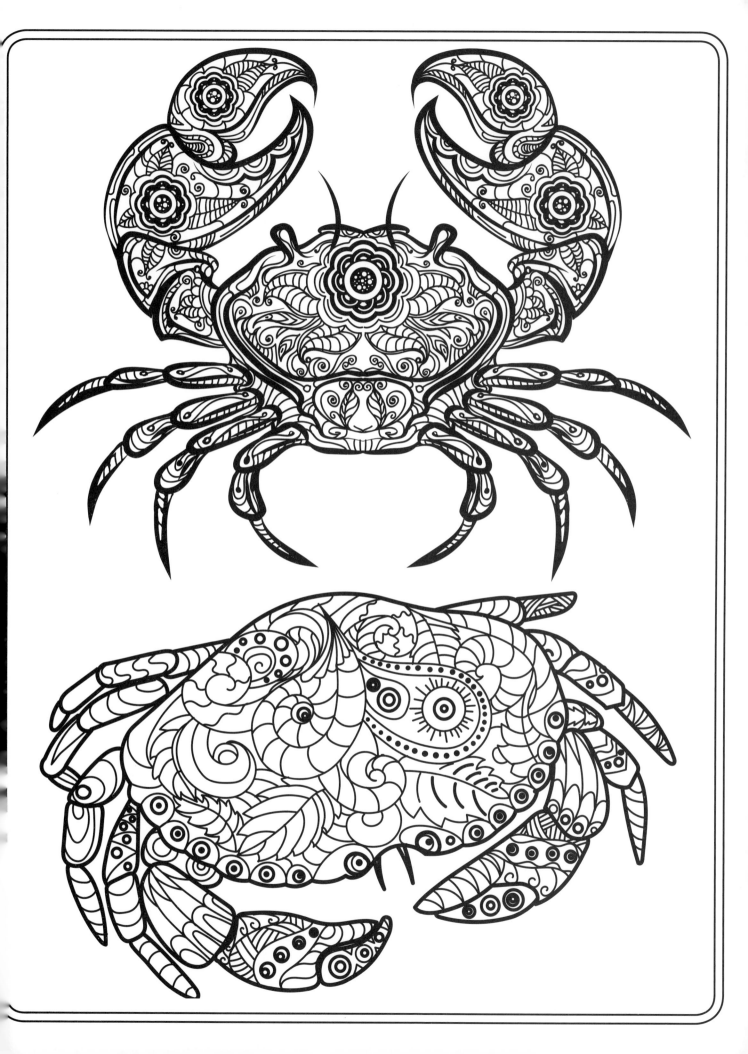

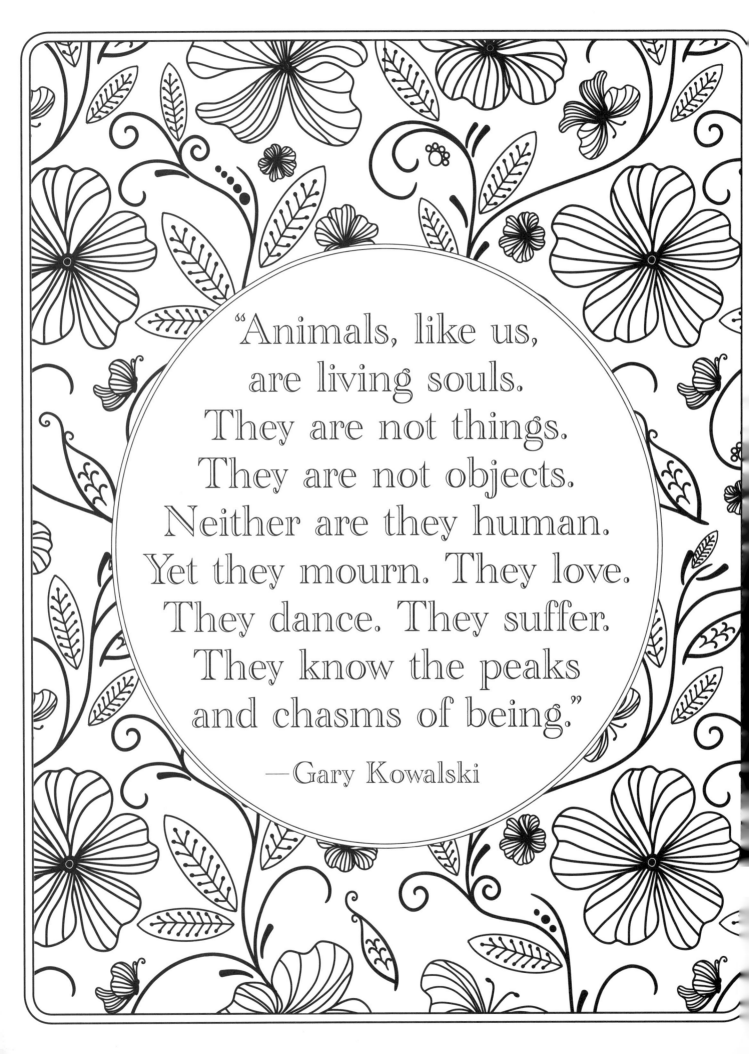

"Animals, like us,
are living souls.
They are not things.
They are not objects.
Neither are they human.
Yet they mourn. They love.
They dance. They suffer.
They know the peaks
and chasms of being."

—Gary Kowalski

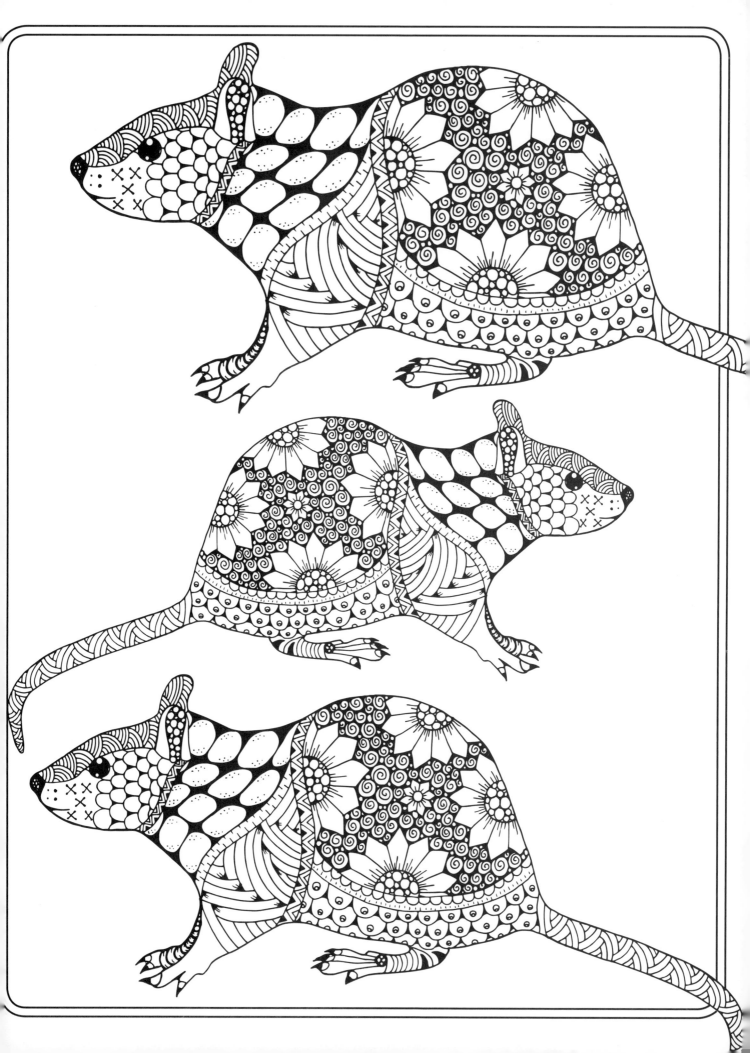

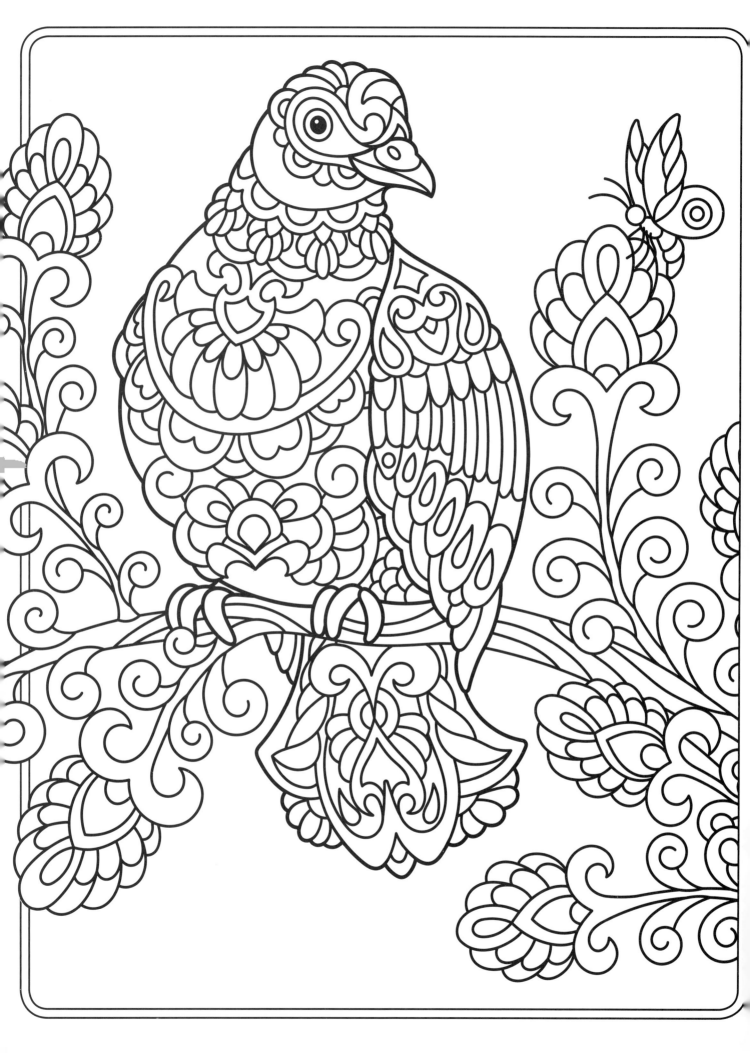

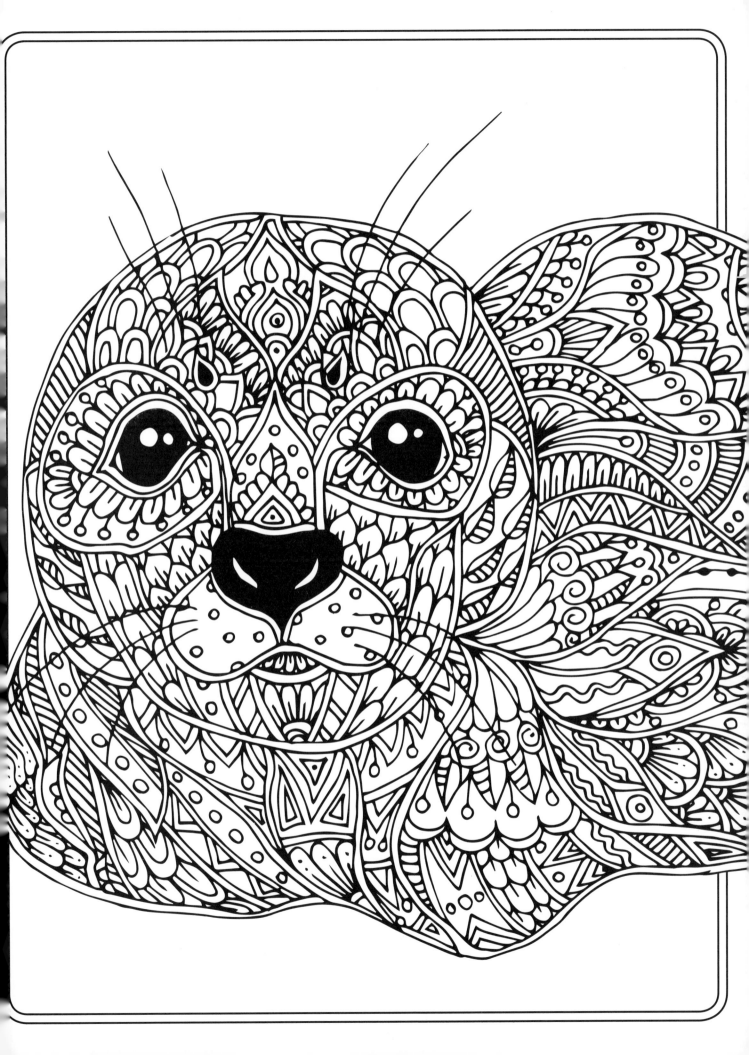

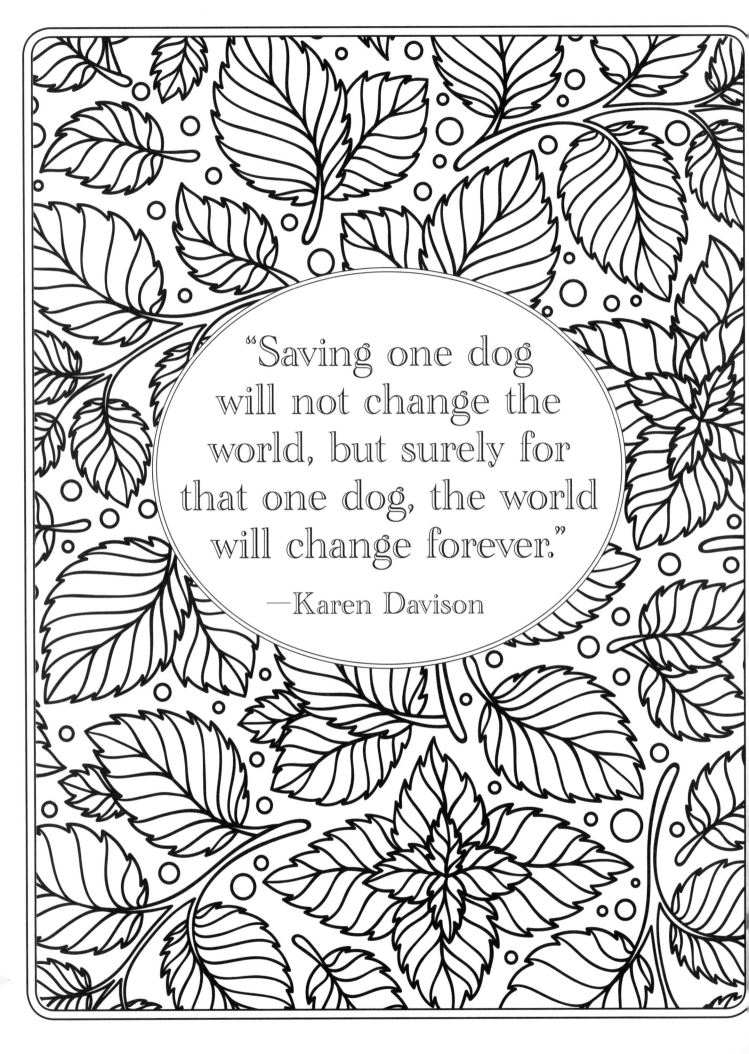

"Saving one dog
will not change the
world, but surely for
that one dog, the world
will change forever."

—Karen Davison

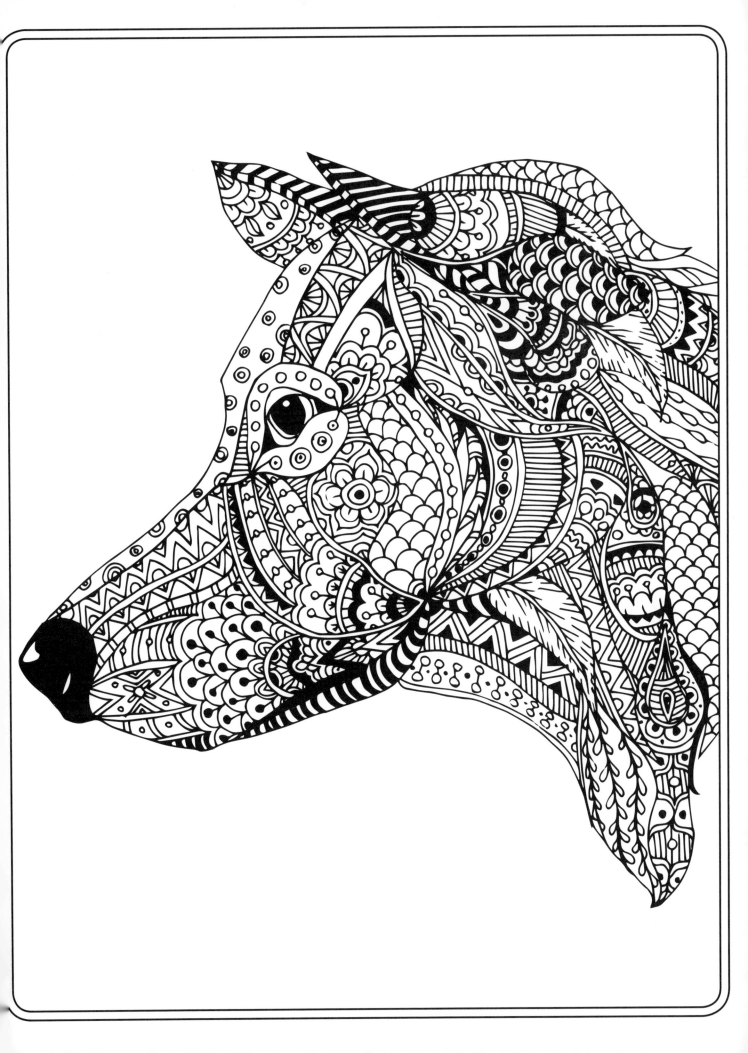

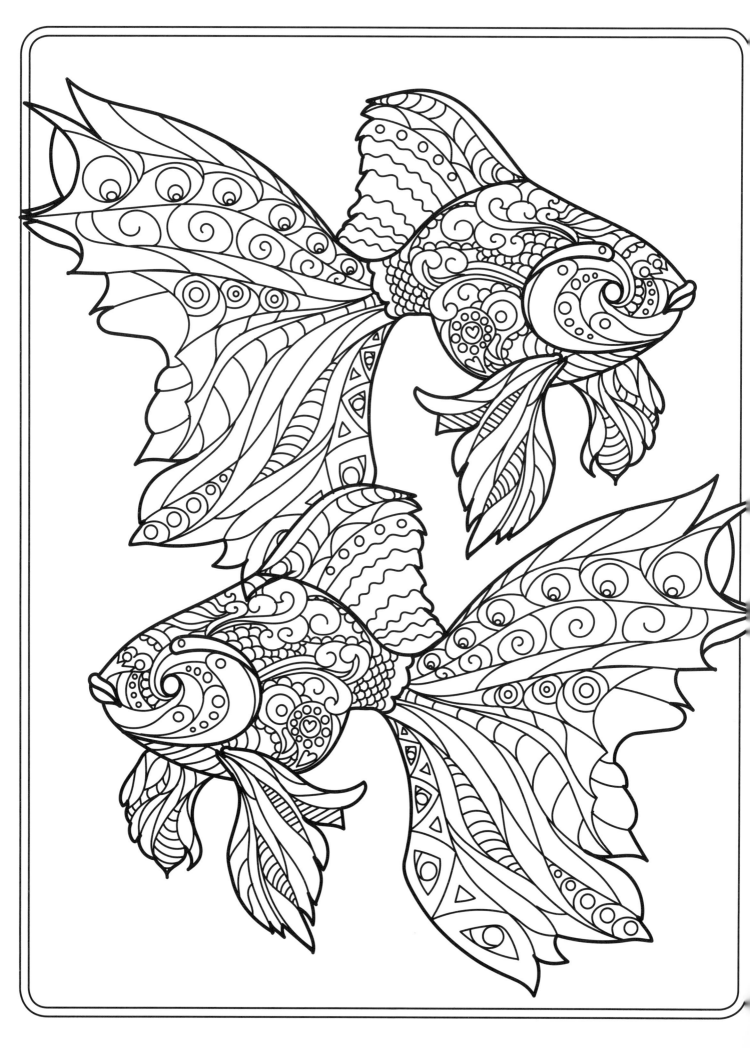

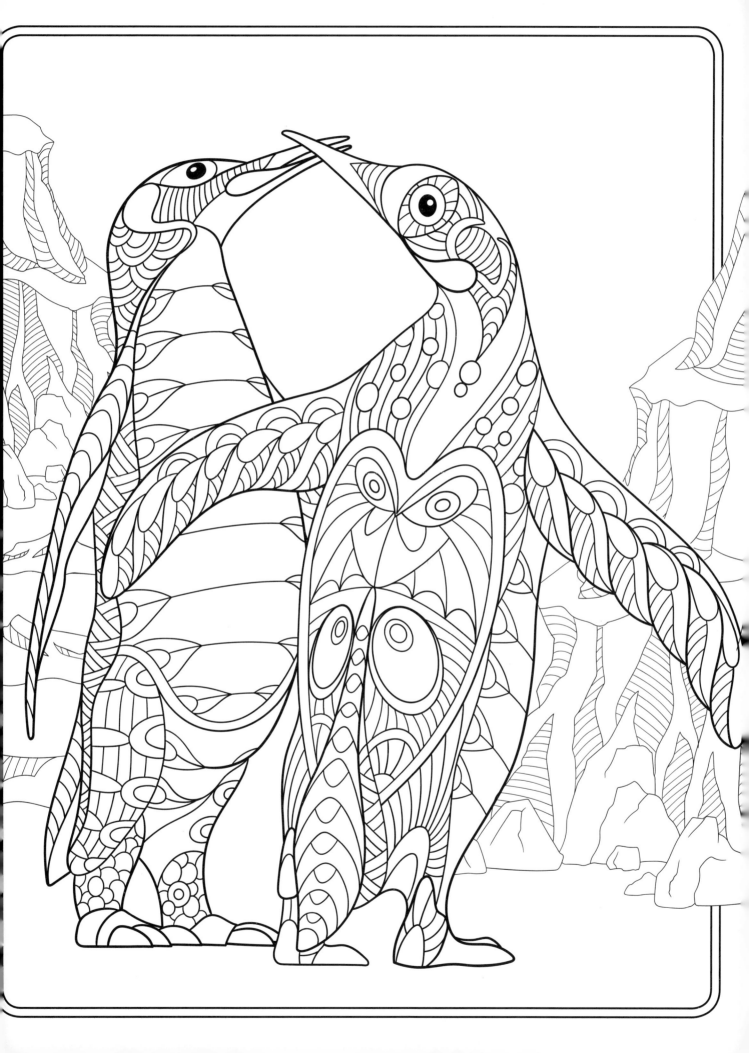

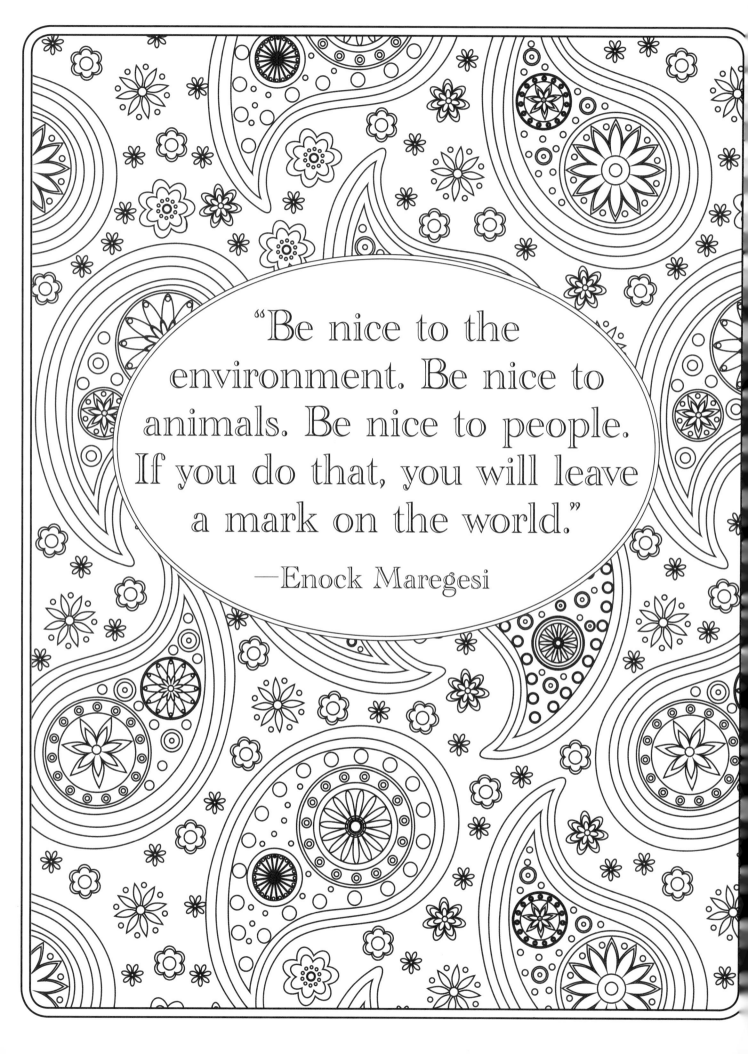

"Be nice to the environment. Be nice to animals. Be nice to people. If you do that, you will leave a mark on the world."

—Enock Maregesi

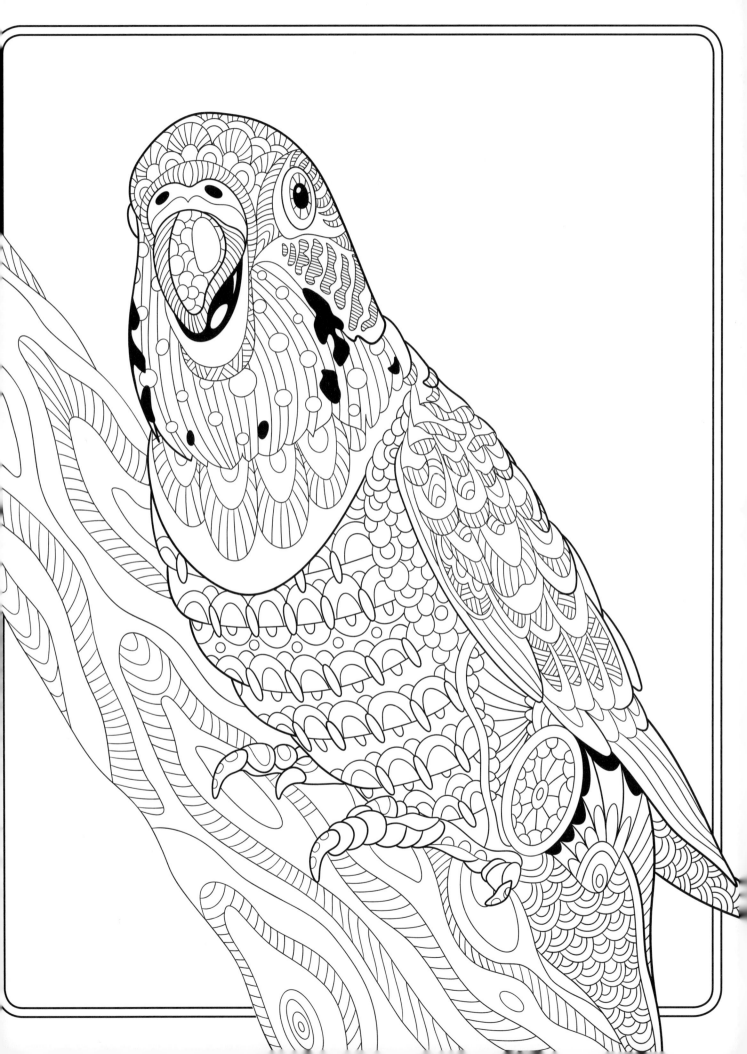

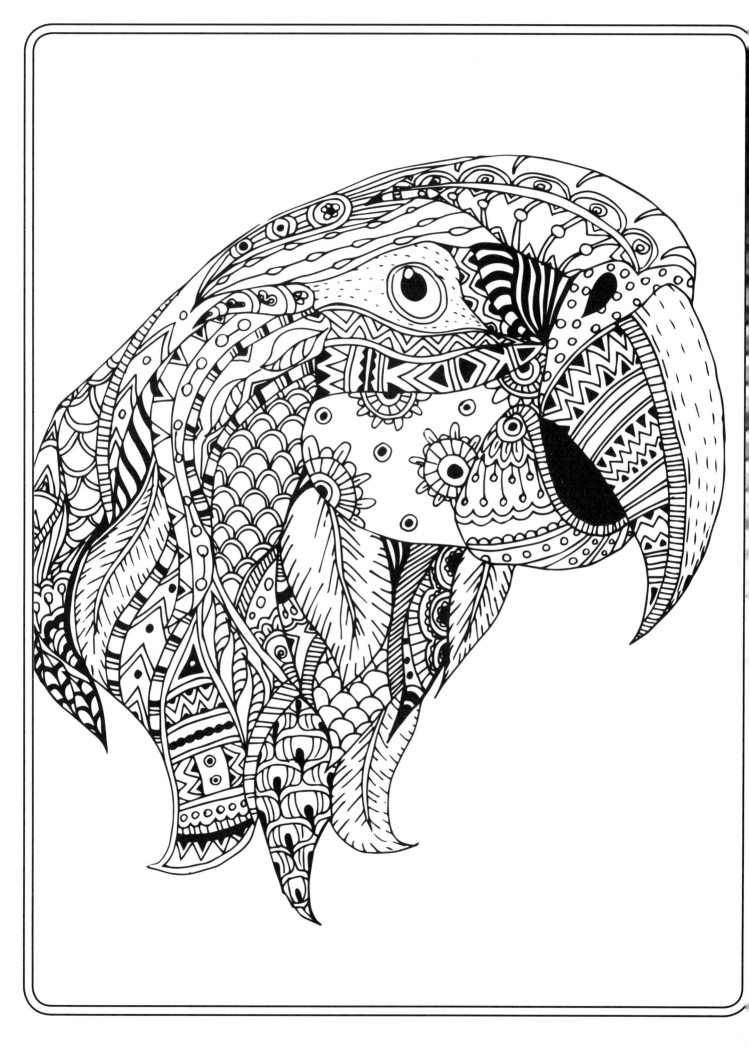

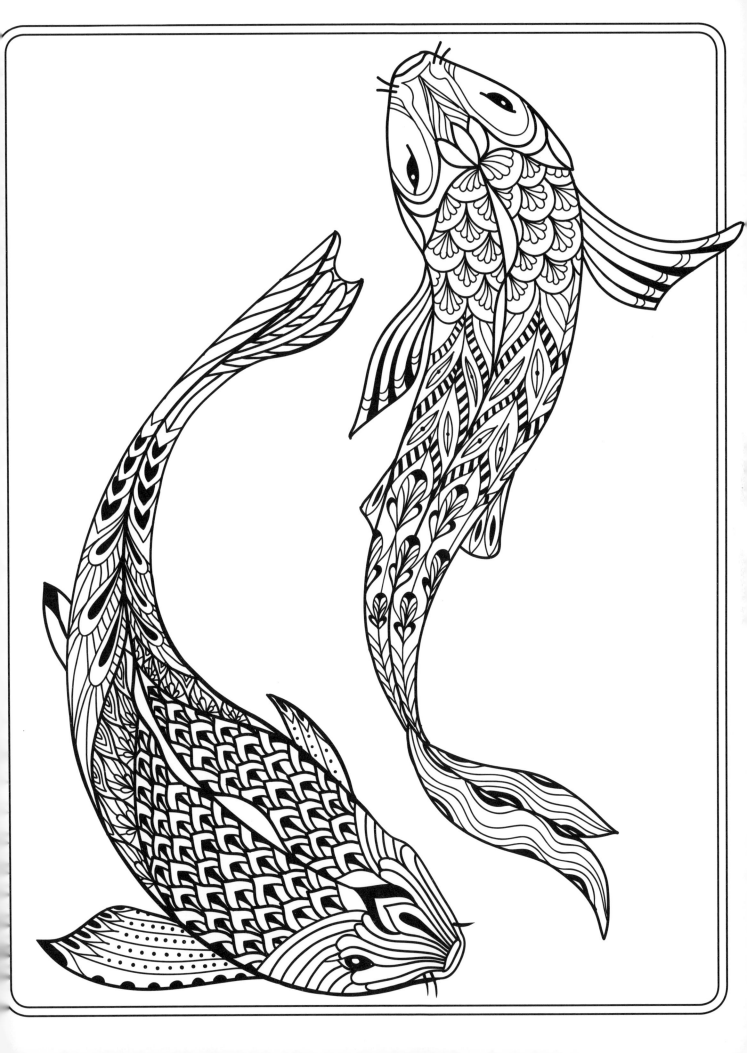

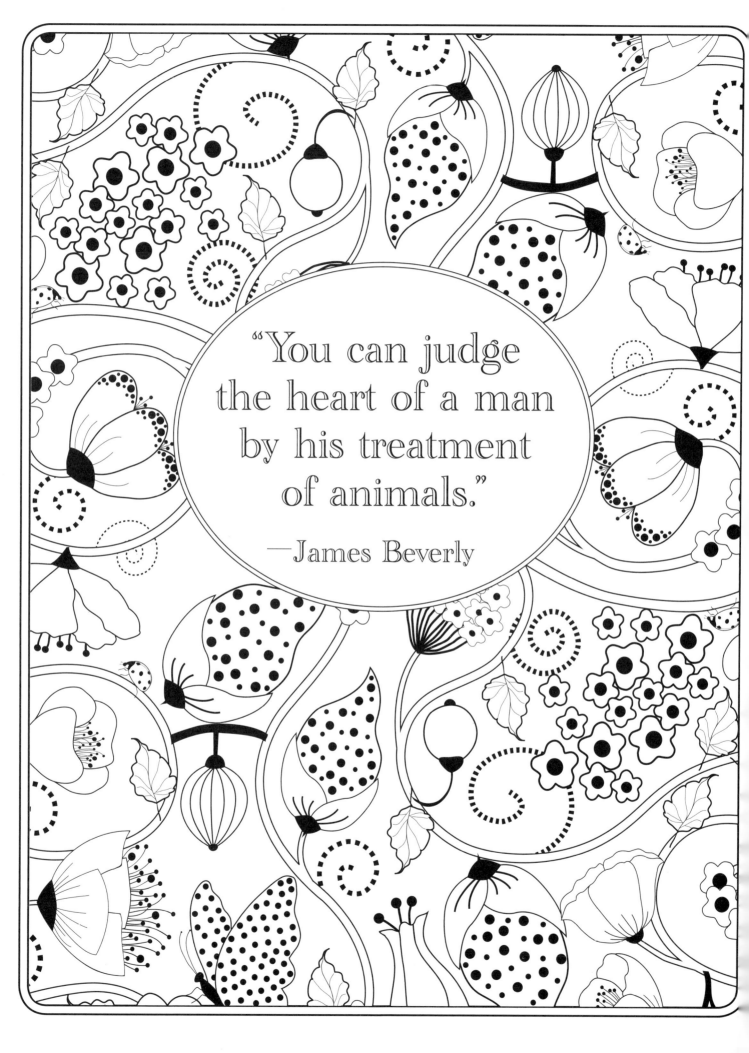

"You can judge
the heart of a man
by his treatment
of animals."

—James Beverly

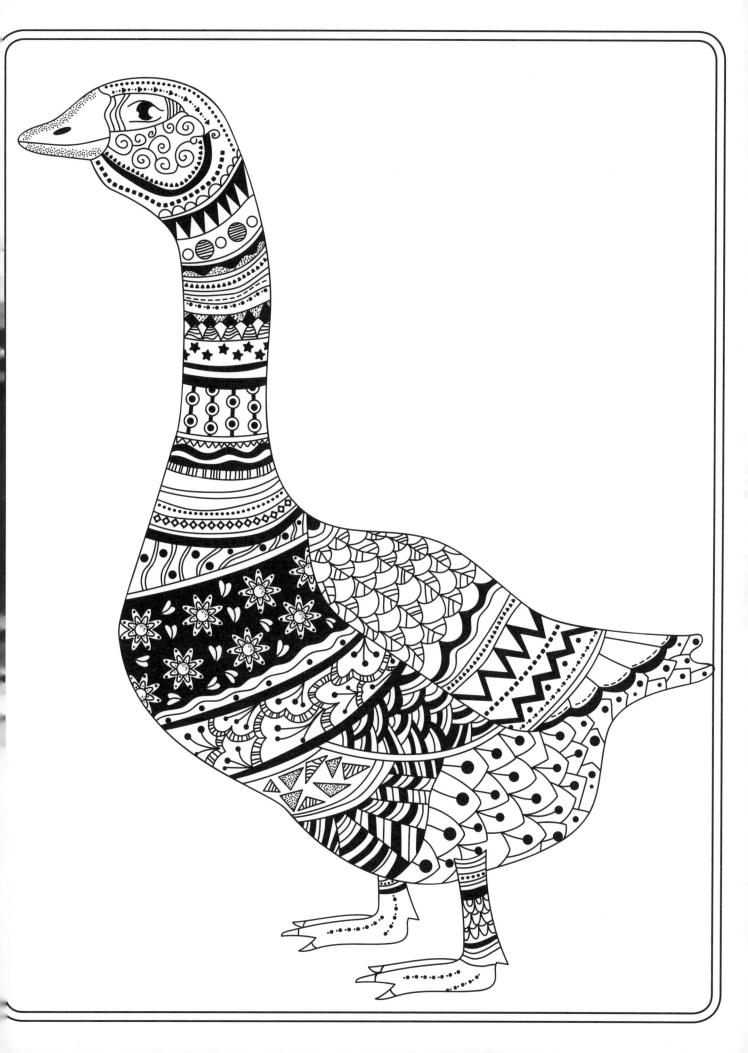

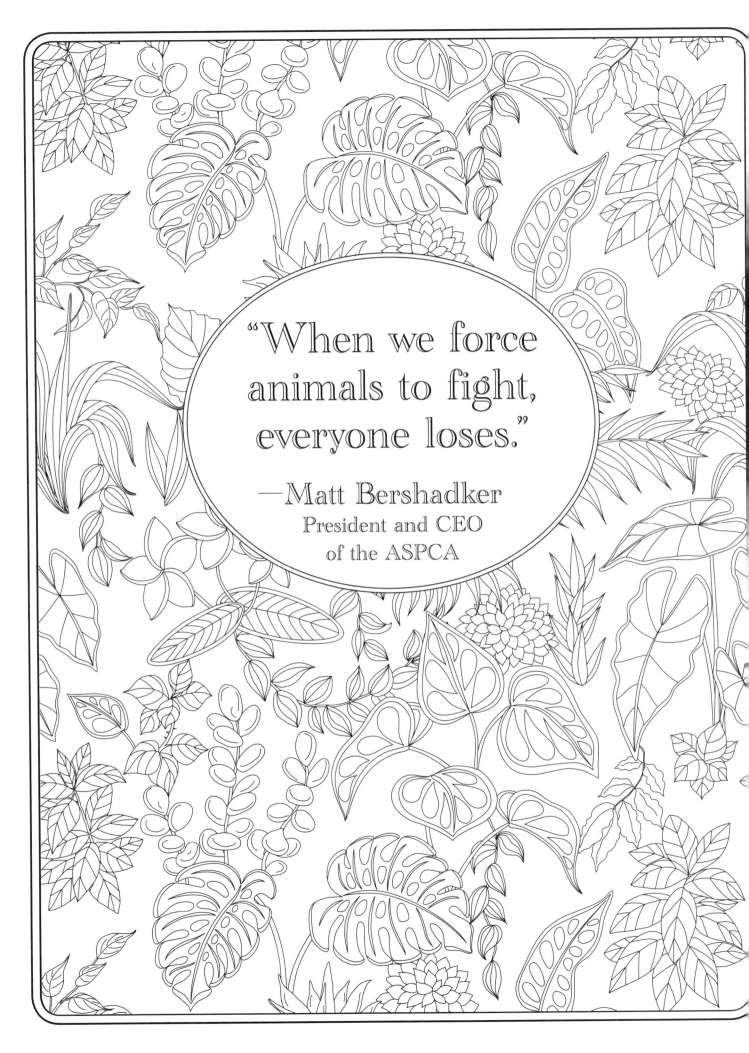

"When we force animals to fight, everyone loses."

—Matt Bershadker
President and CEO
of the ASPCA

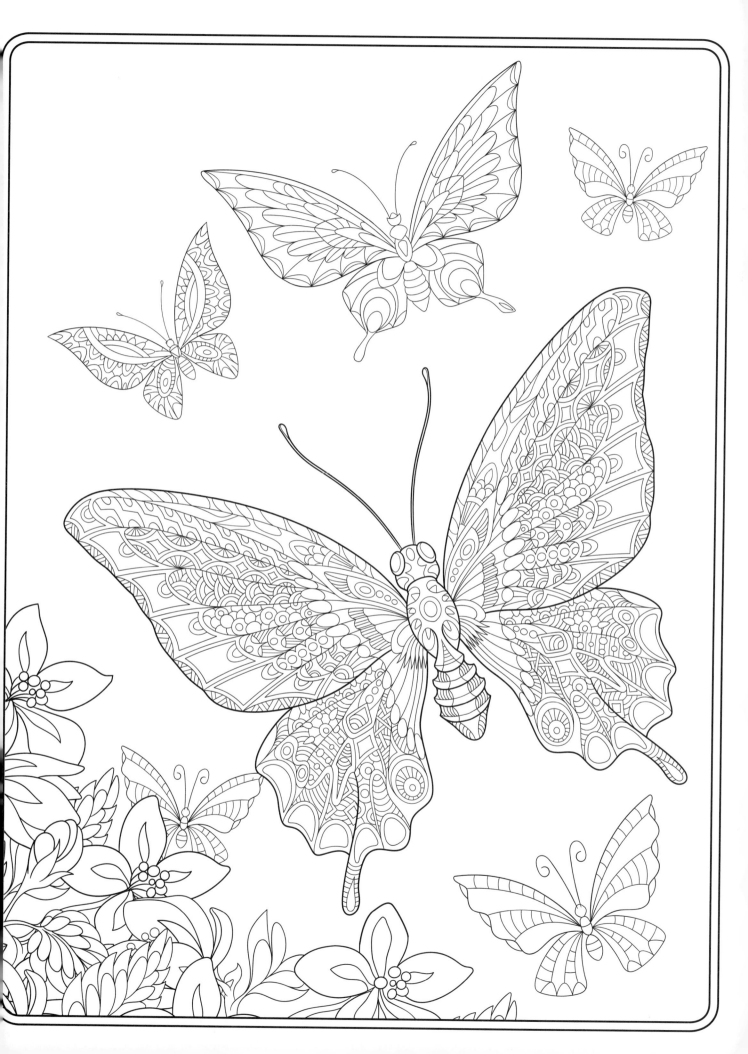

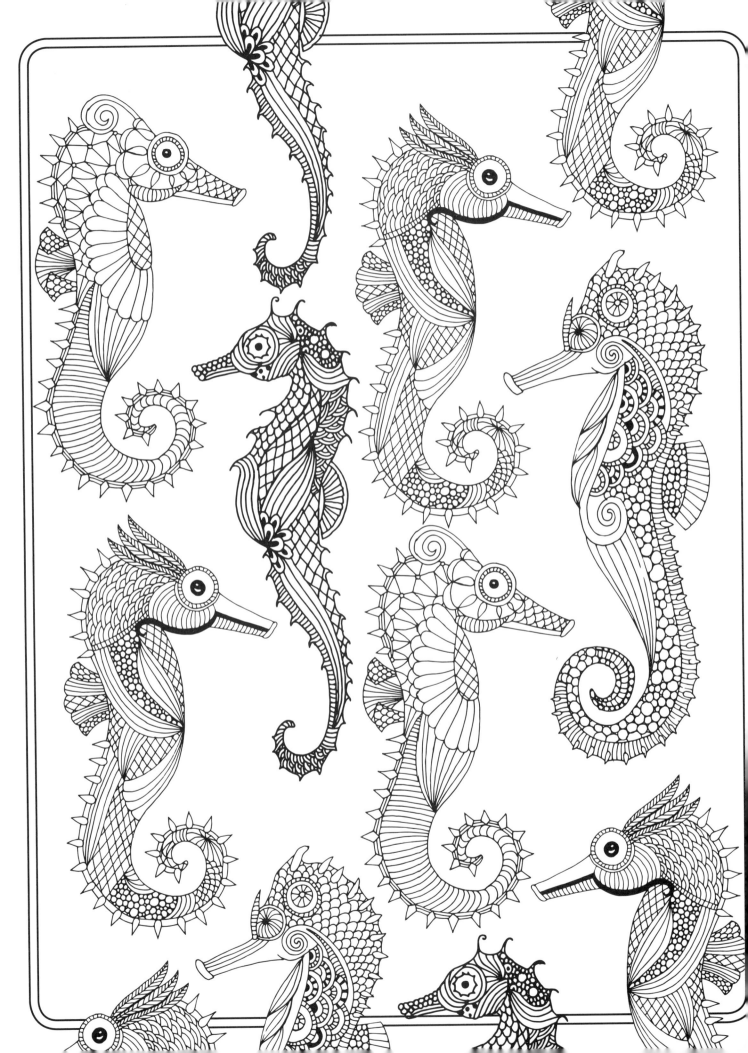

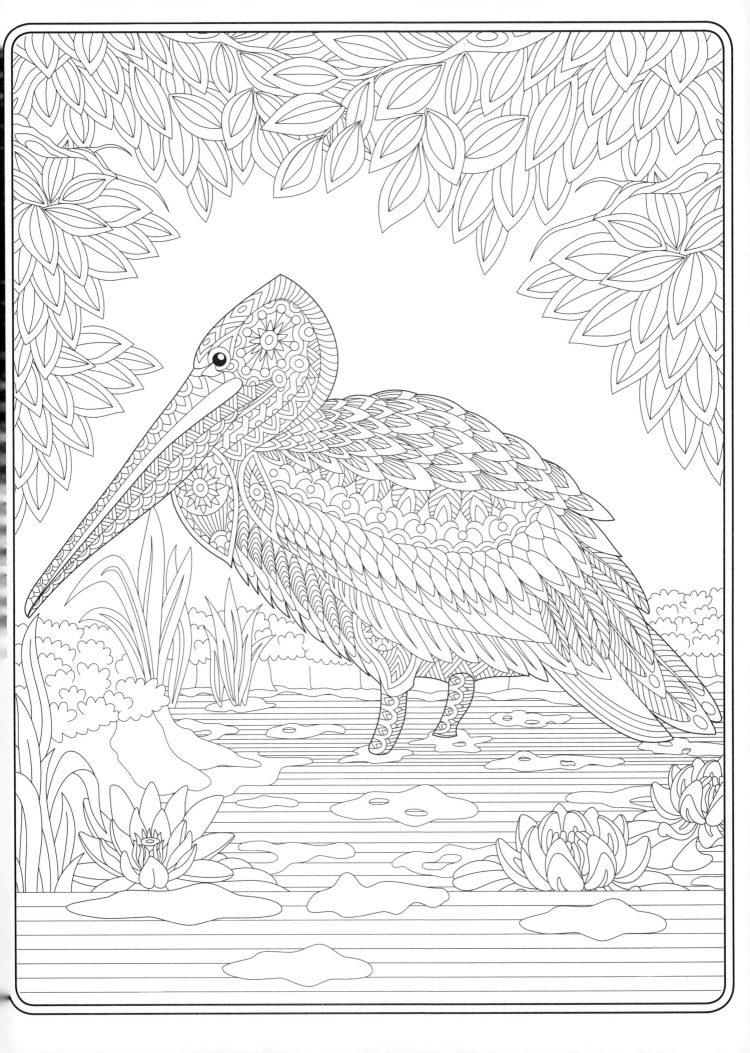

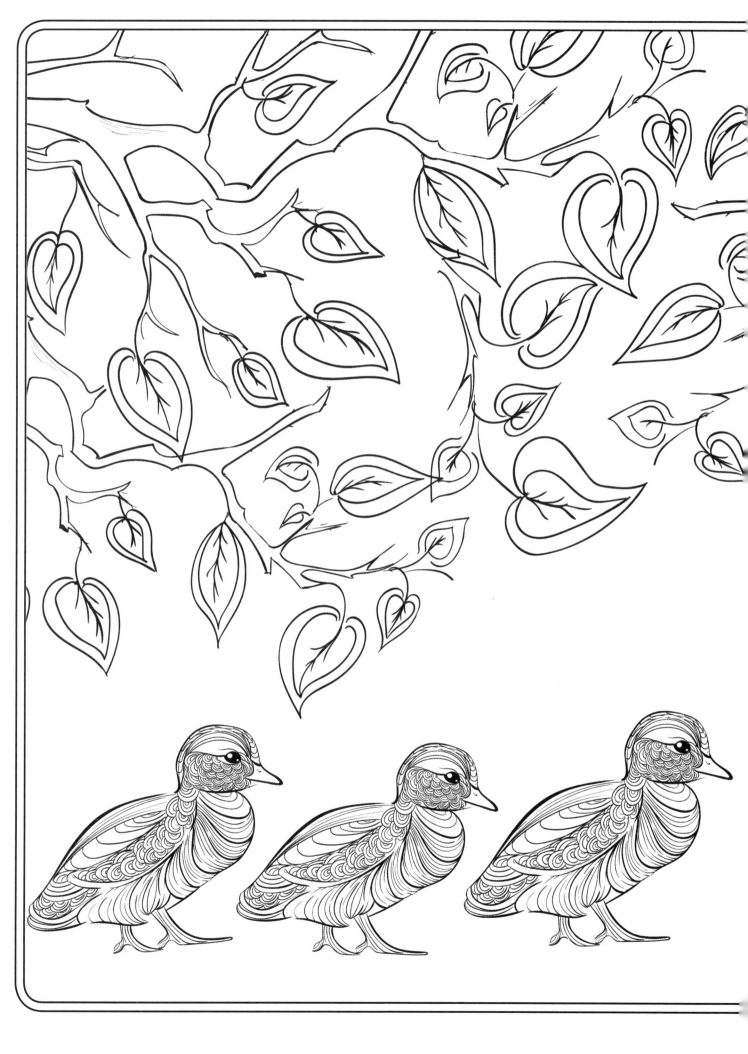

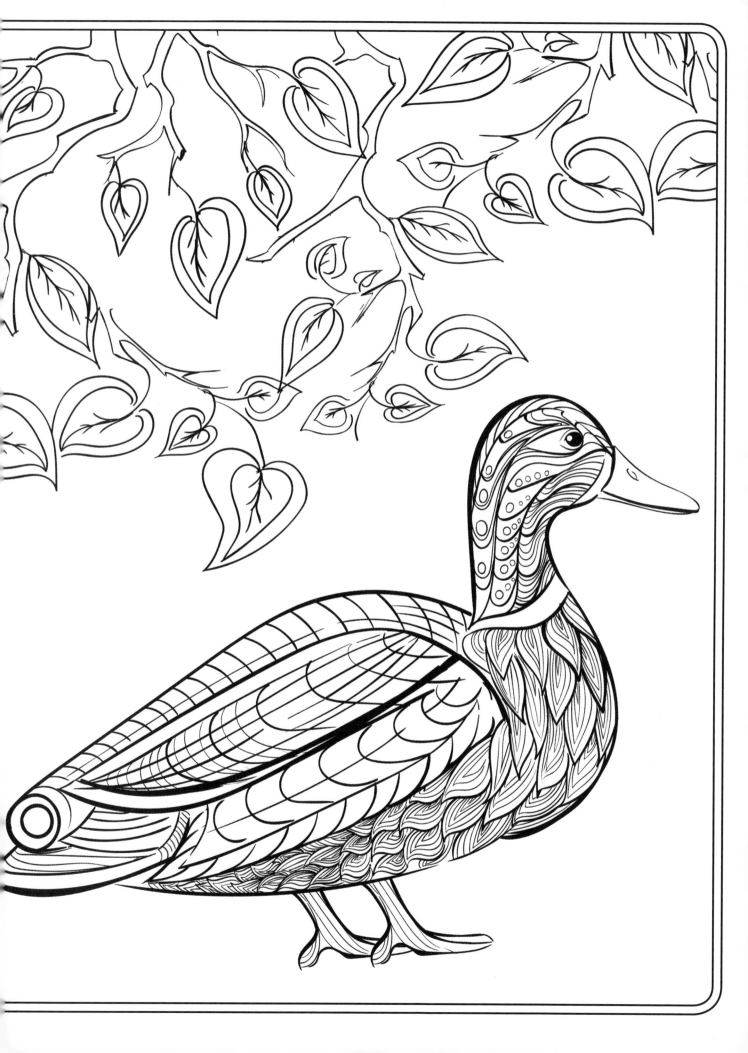

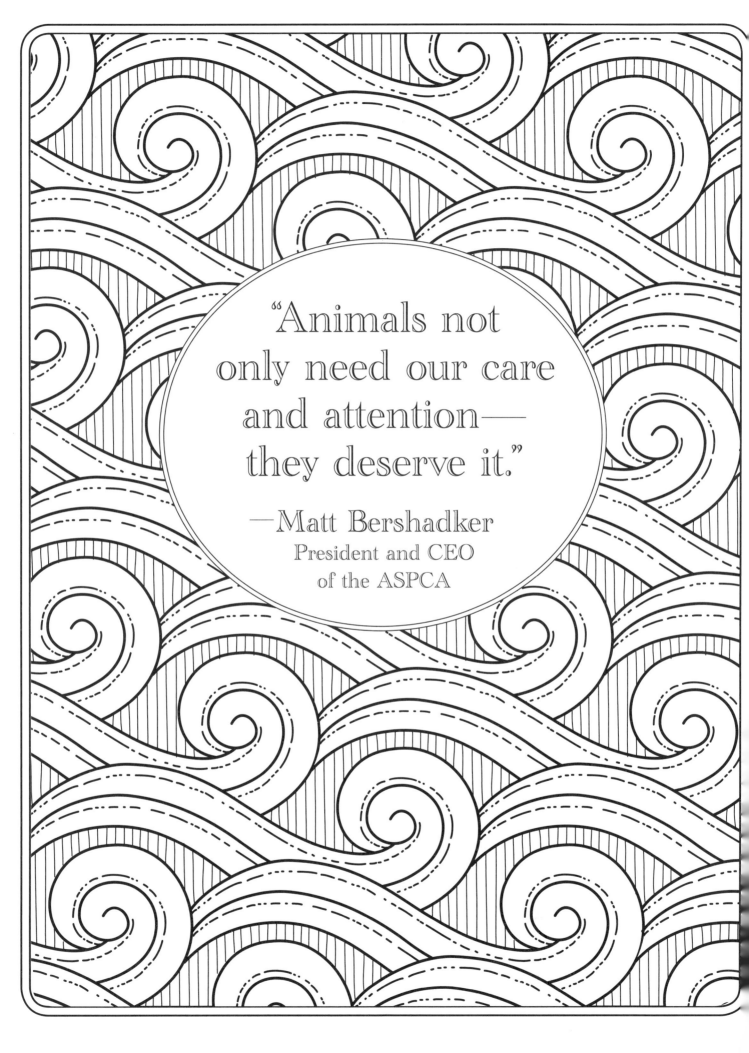

"Animals not
only need our care
and attention—
they deserve it."

—Matt Bershadker
President and CEO
of the ASPCA

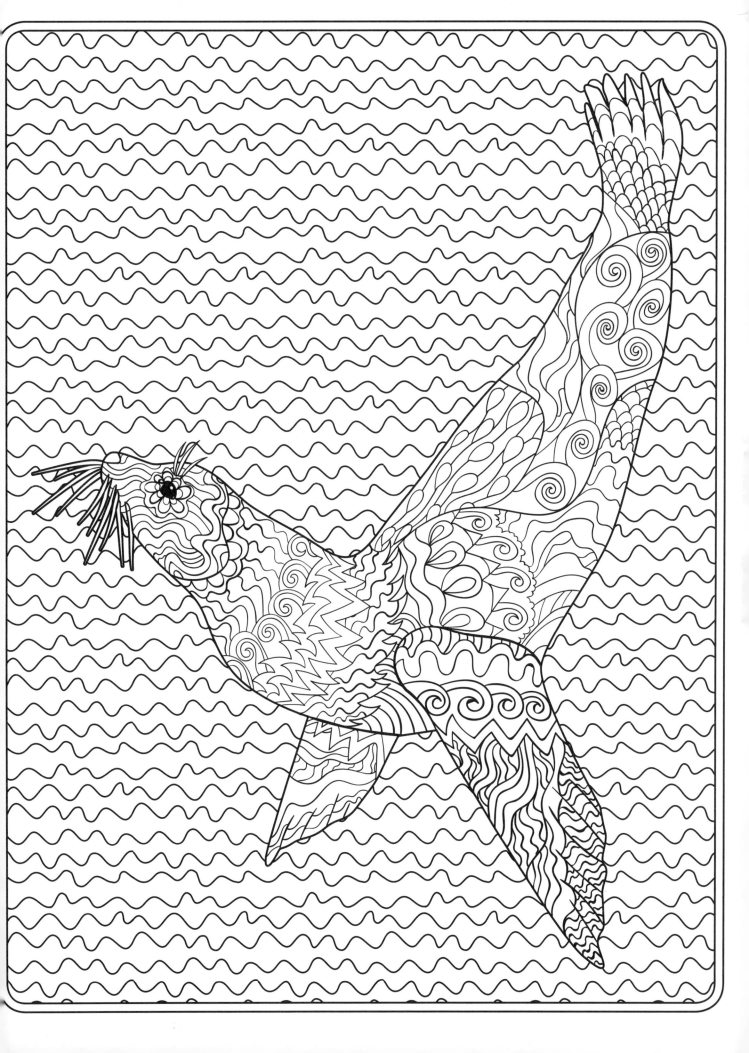

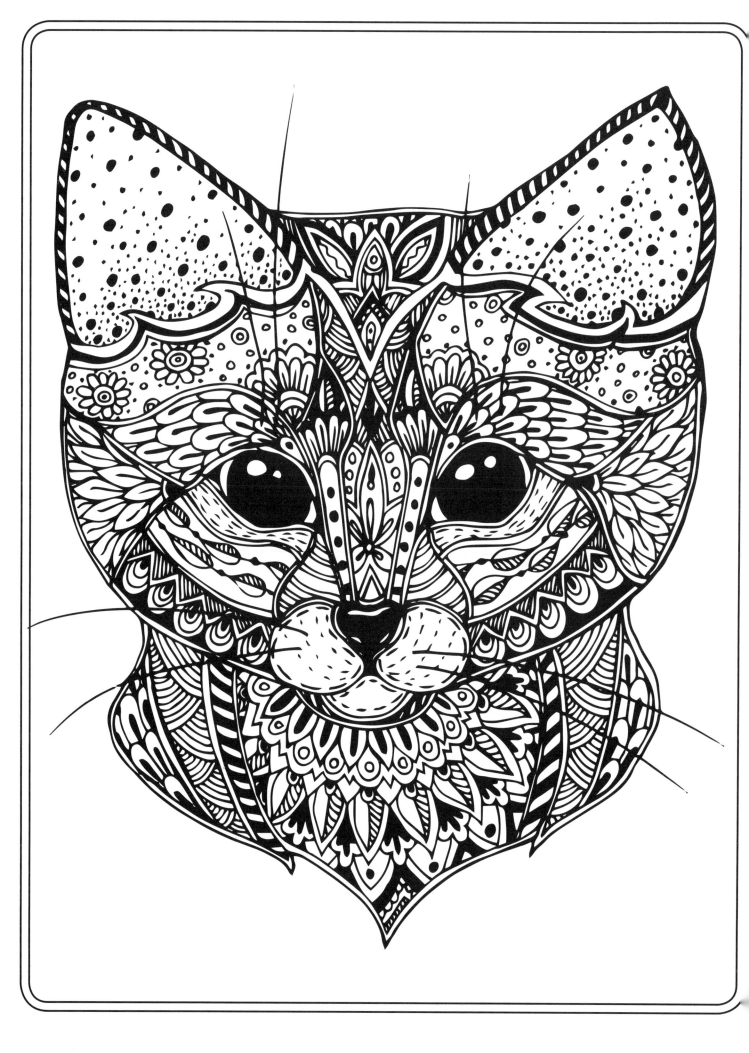

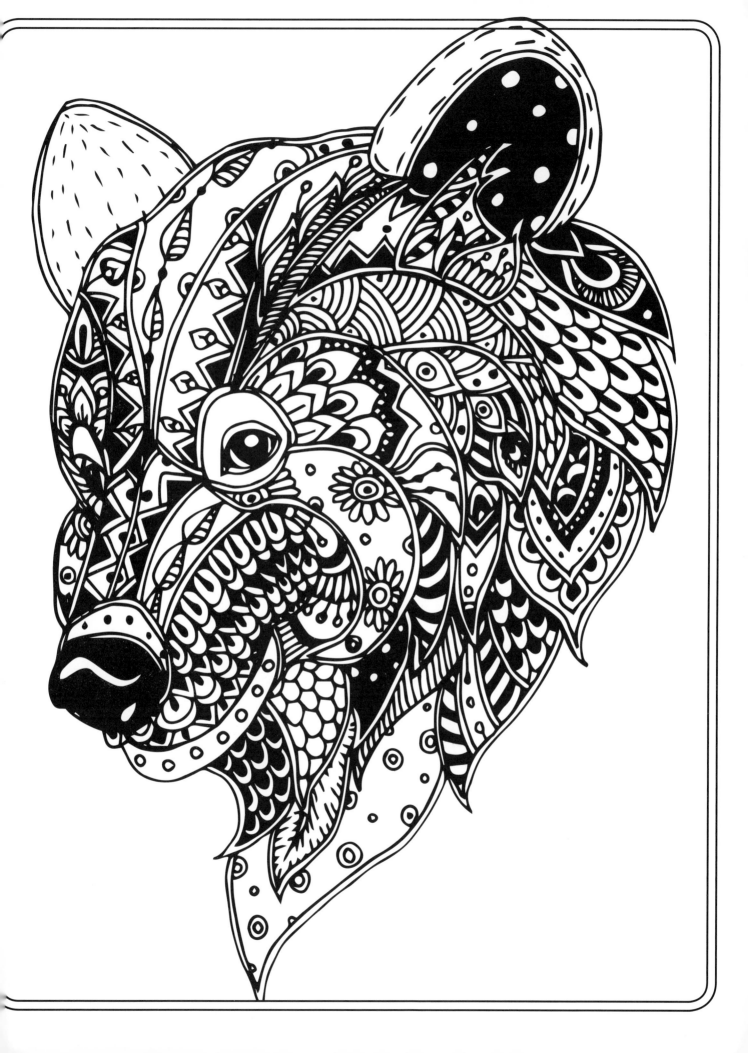

"Besides love and sympathy, animals exhibit other qualities connected with the social instincts which in us would be called moral."

—Charles Darwin

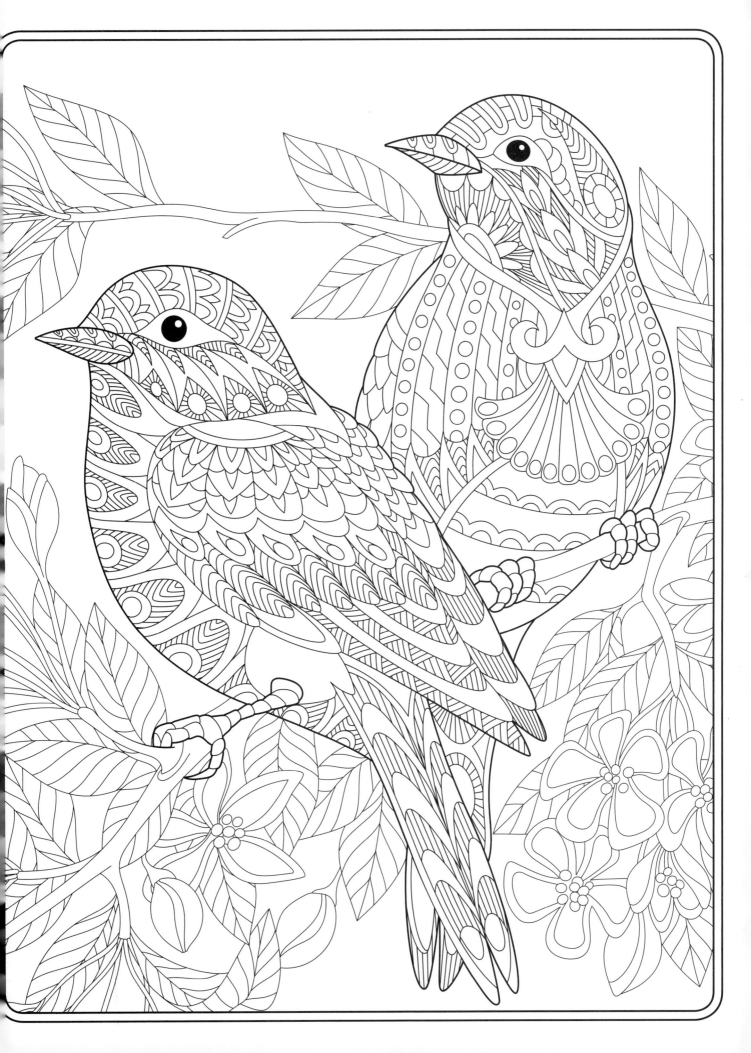

"I have felt cats
rubbing their faces against
mine and touching my cheek
with claws carefully sheathed.
These things, to me, are
expressions of love."

—James Herriot

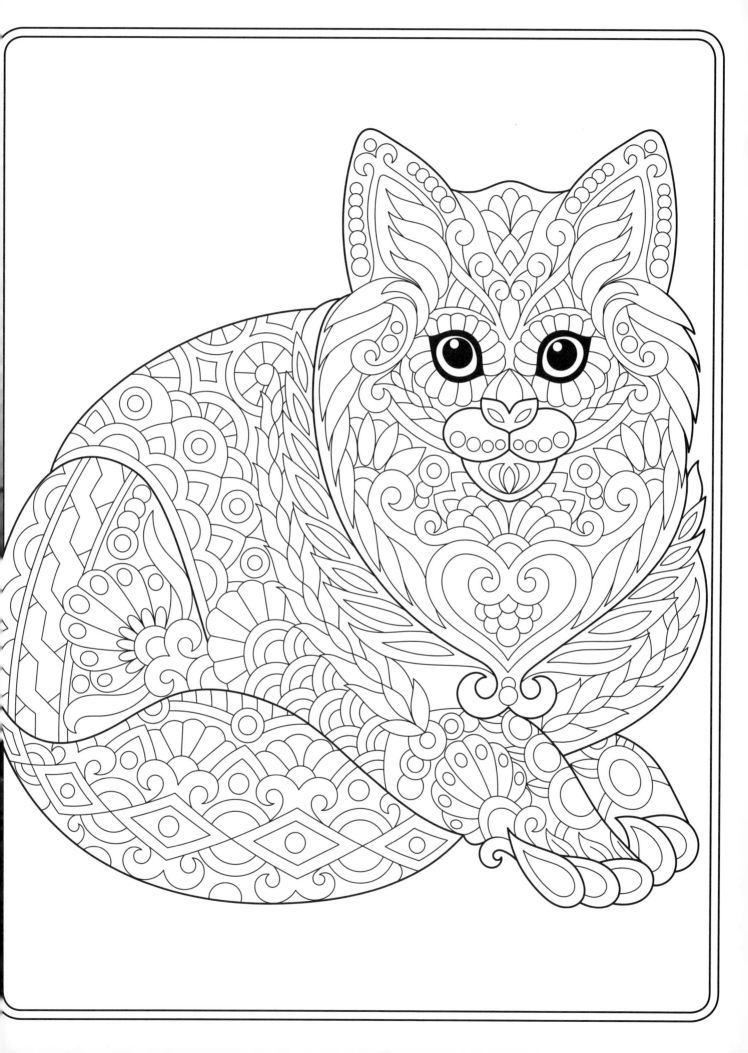

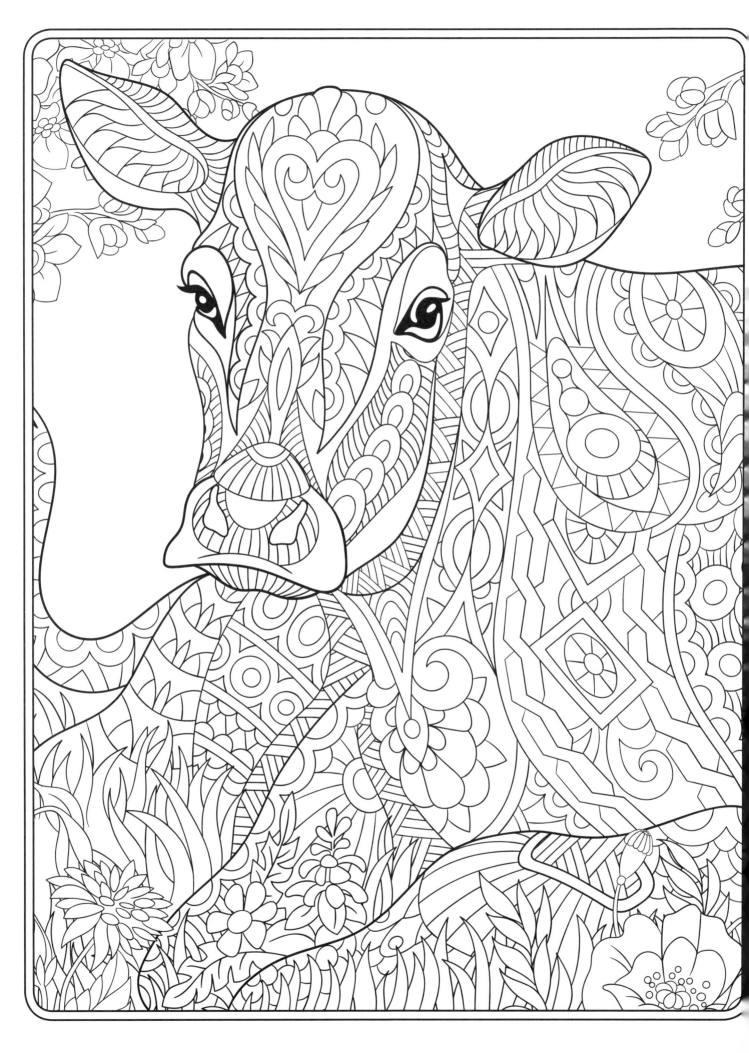

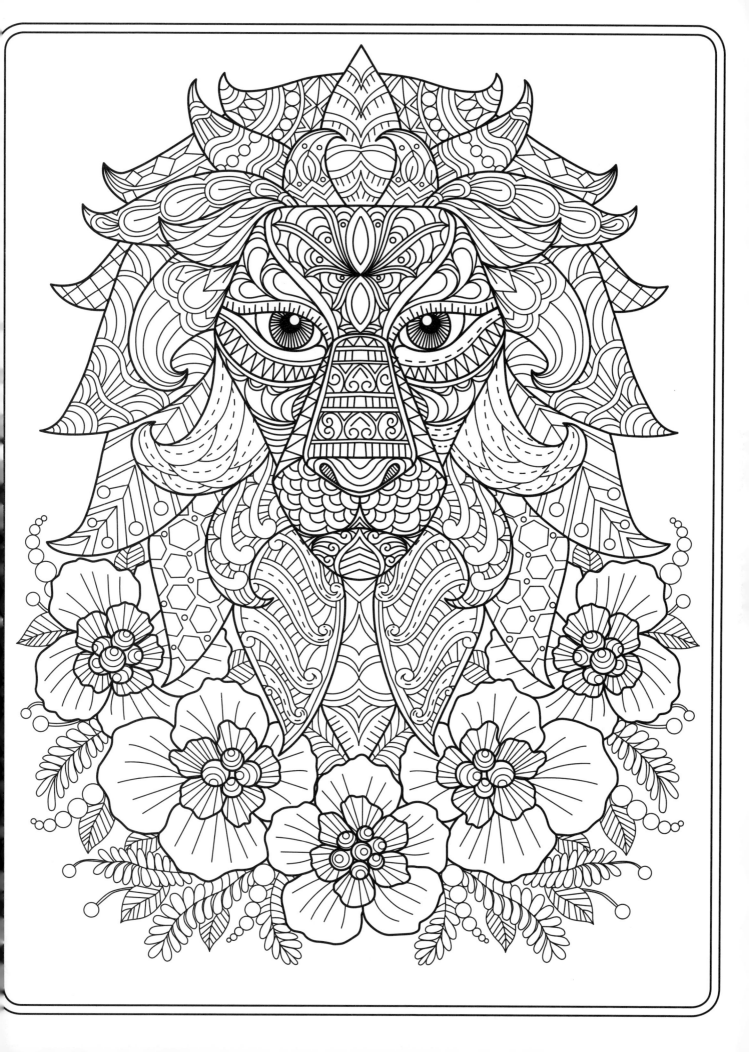

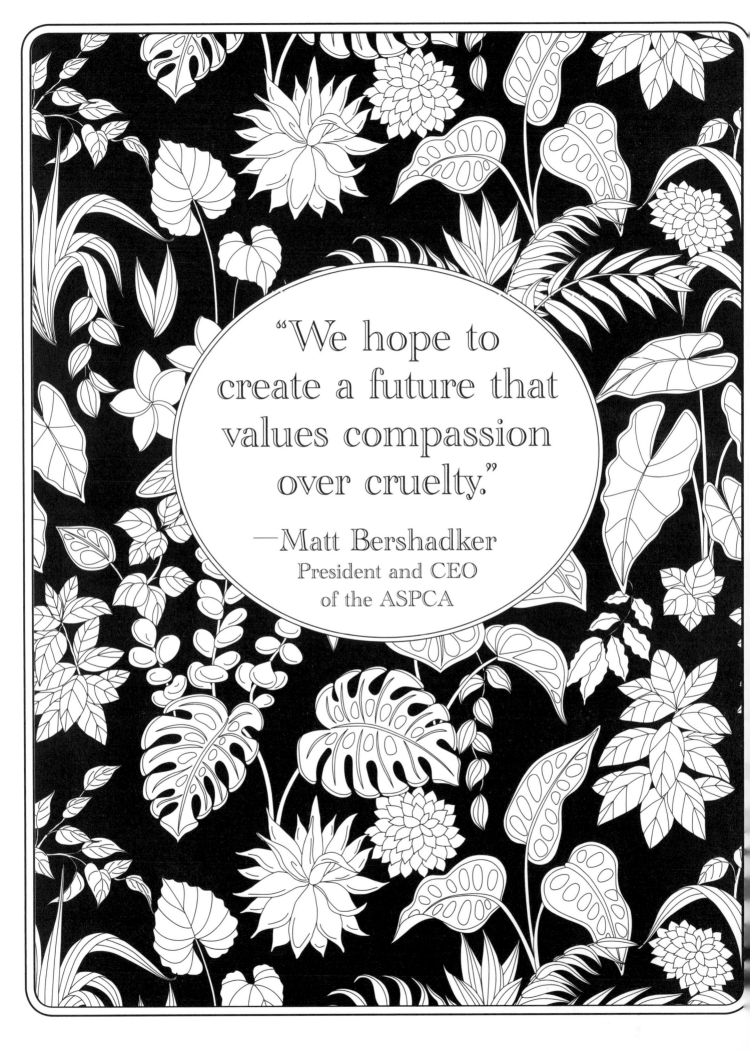

"We hope to create a future that values compassion over cruelty."

—Matt Bershadker
President and CEO
of the ASPCA

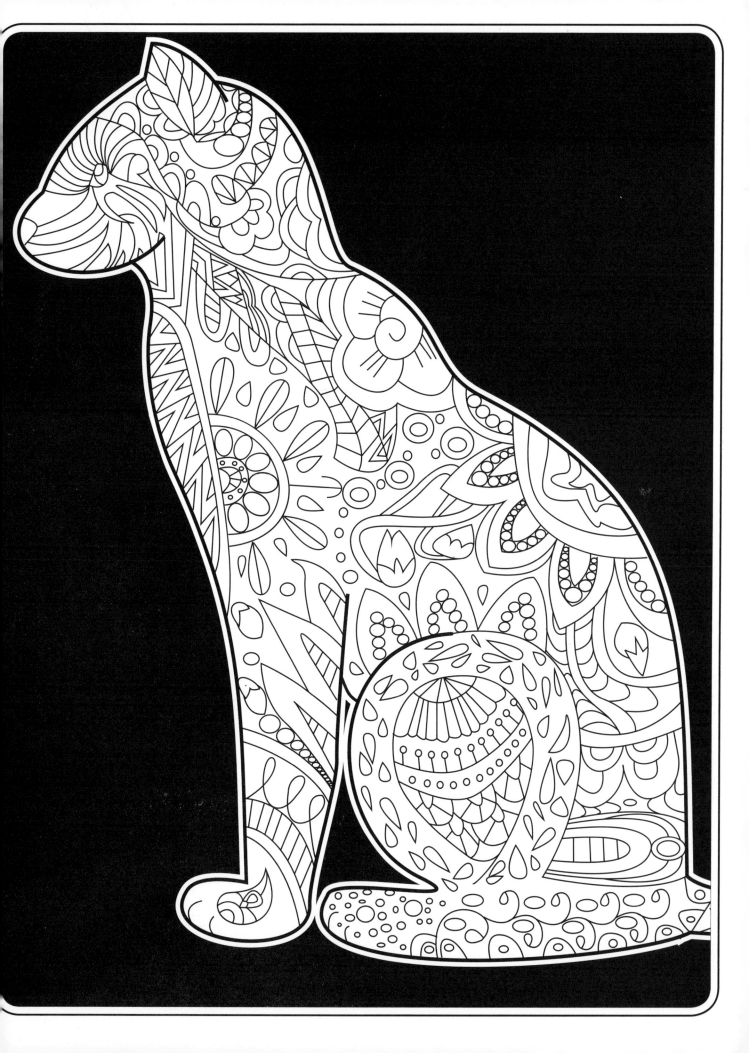

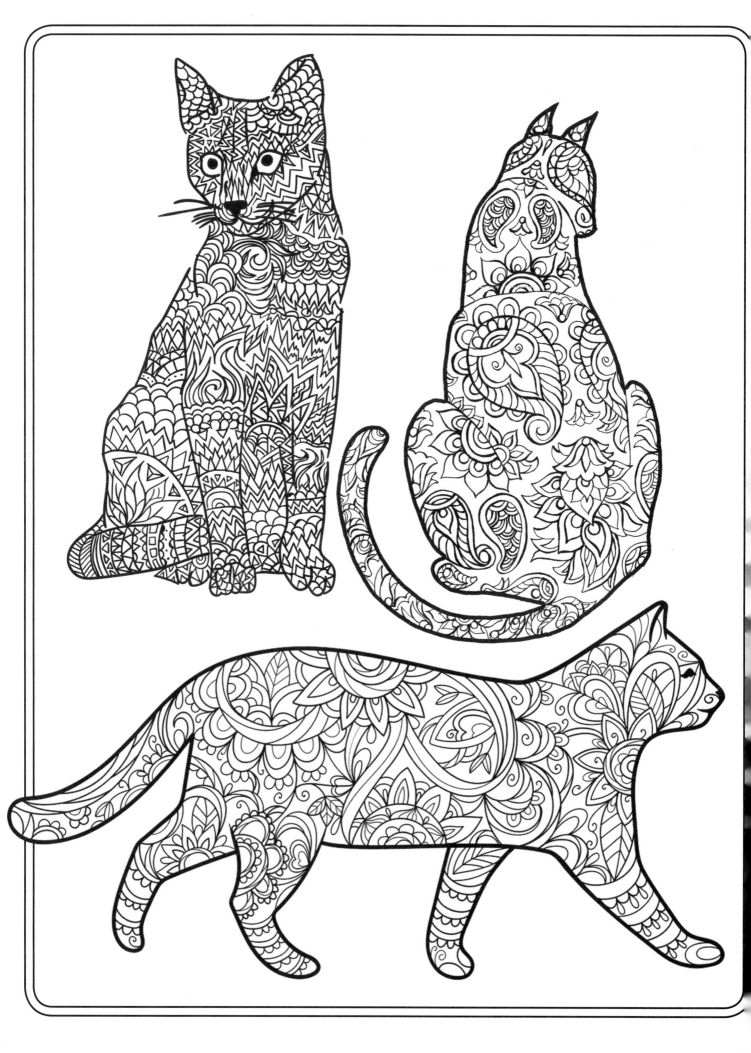

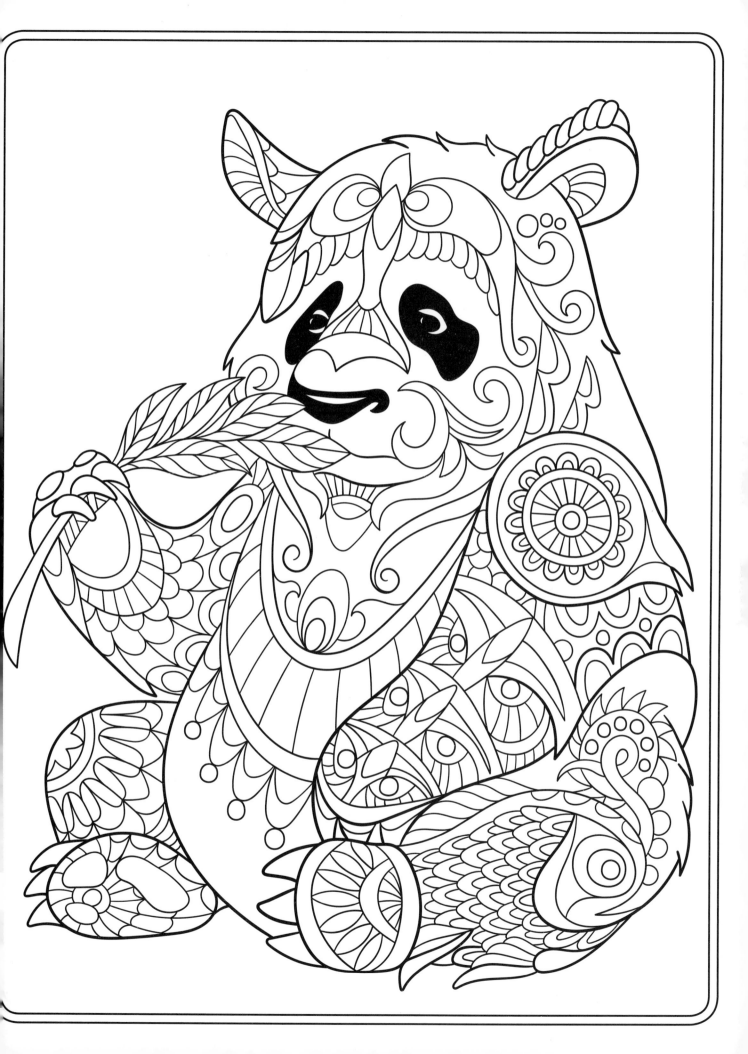

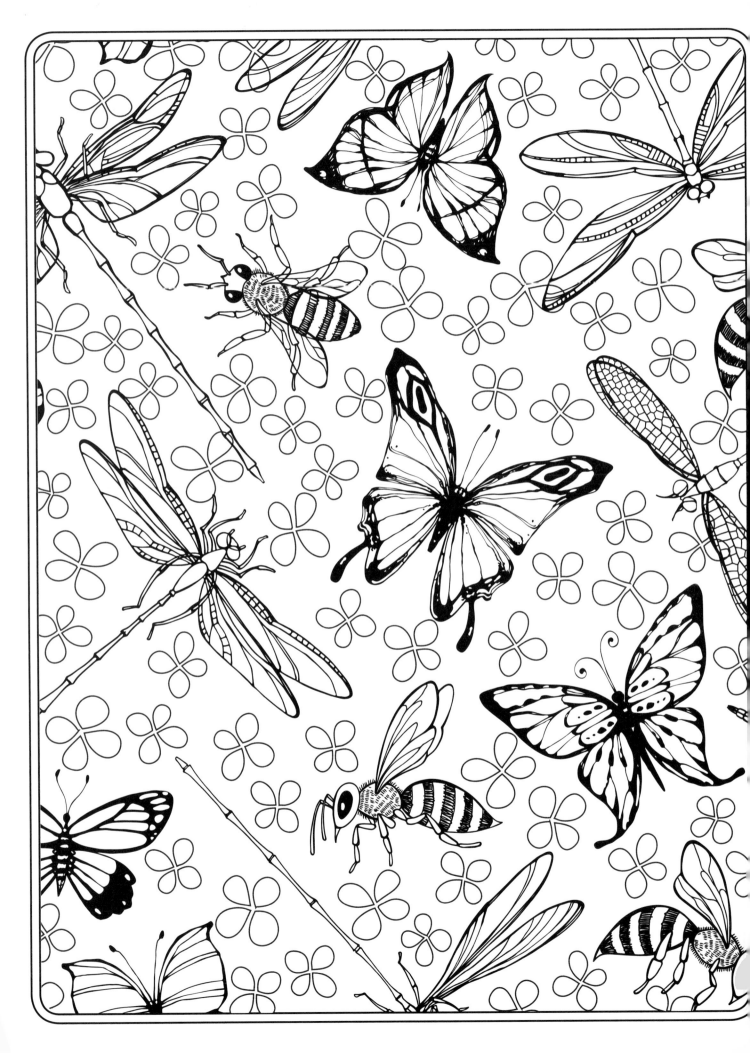

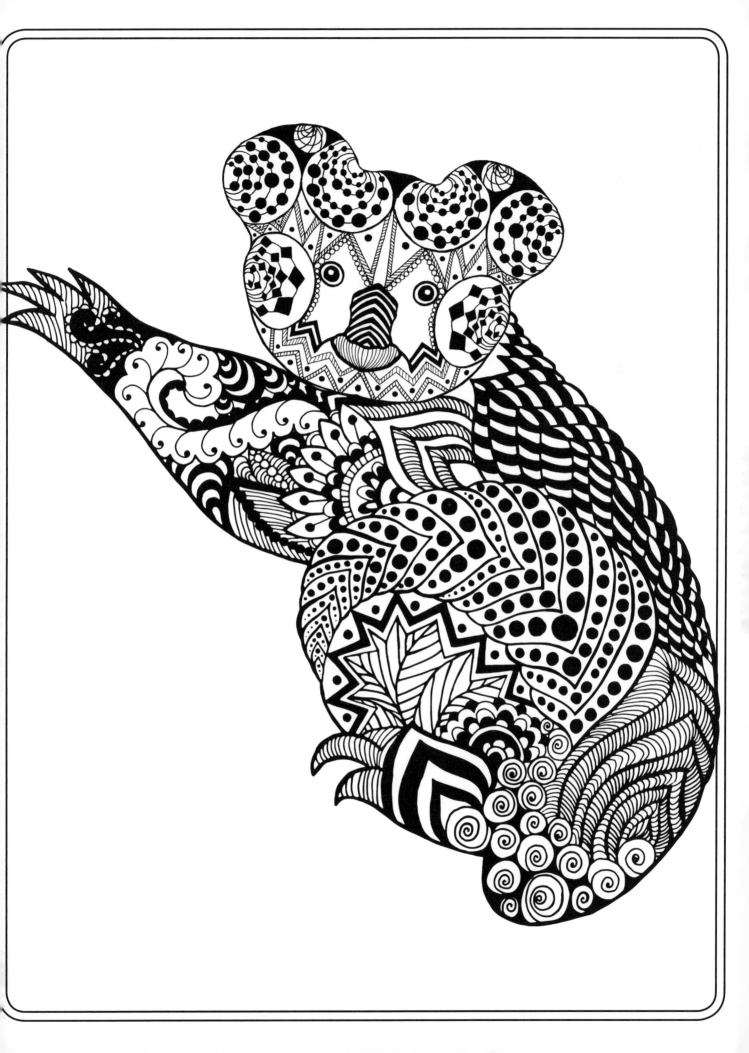

"Whoever declared that love at first sight doesn't exist has never witnessed the purity of a puppy or looked deep into a puppy's eyes. If they did, their lives would change considerably."

—Elizabeth Parker

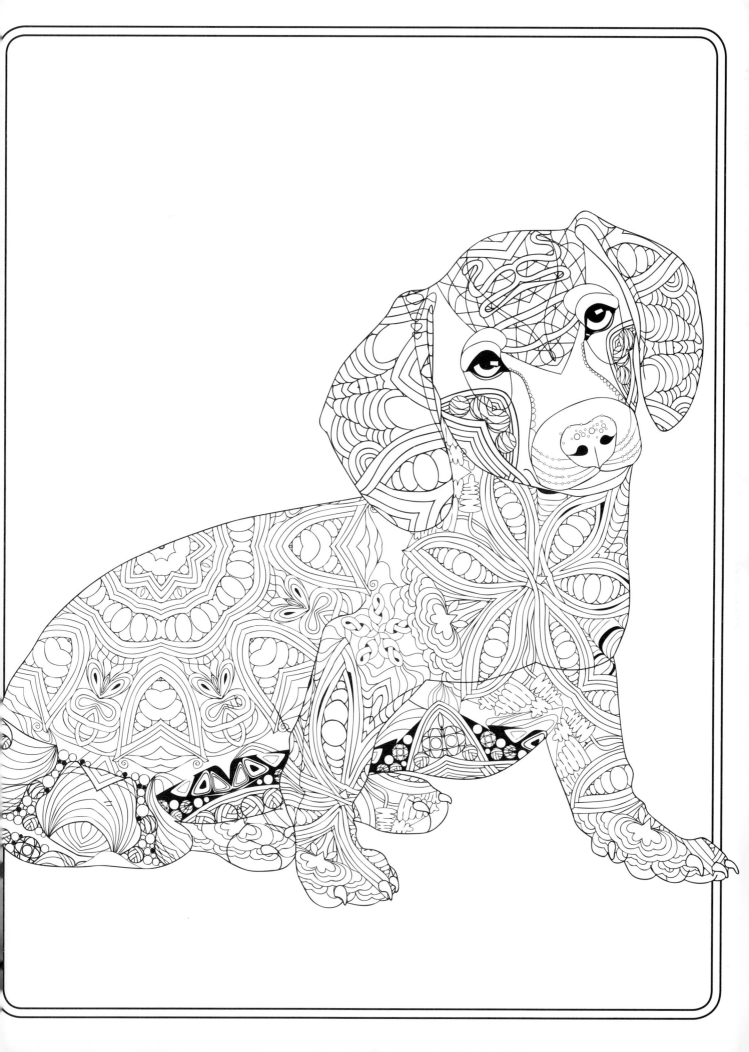

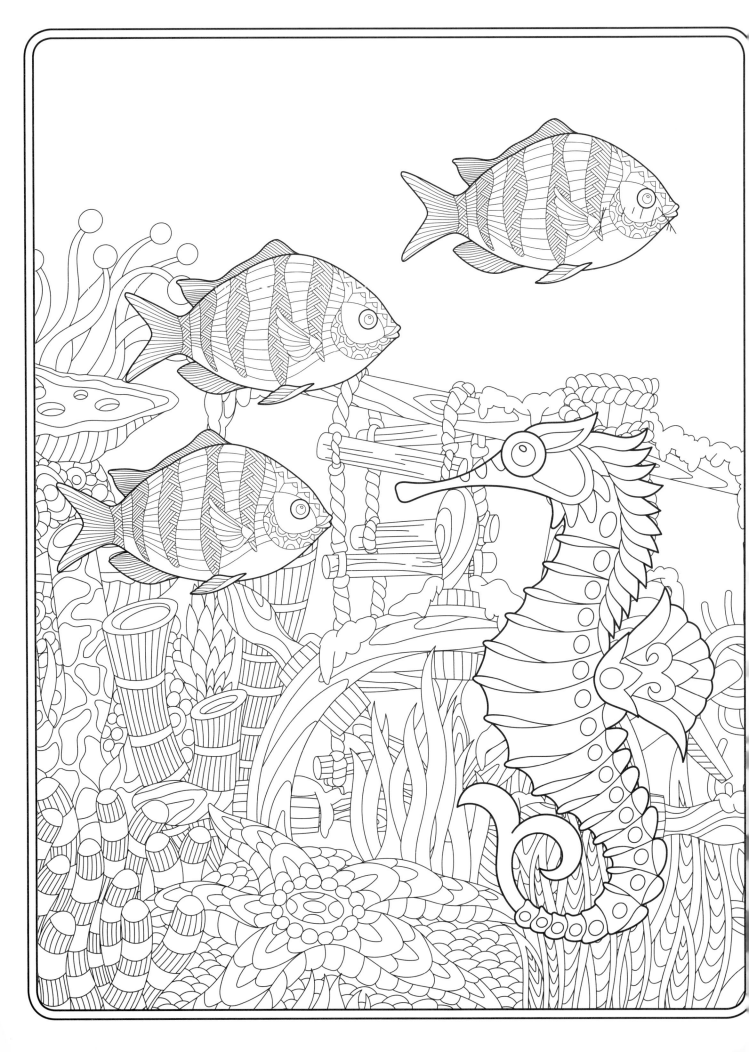

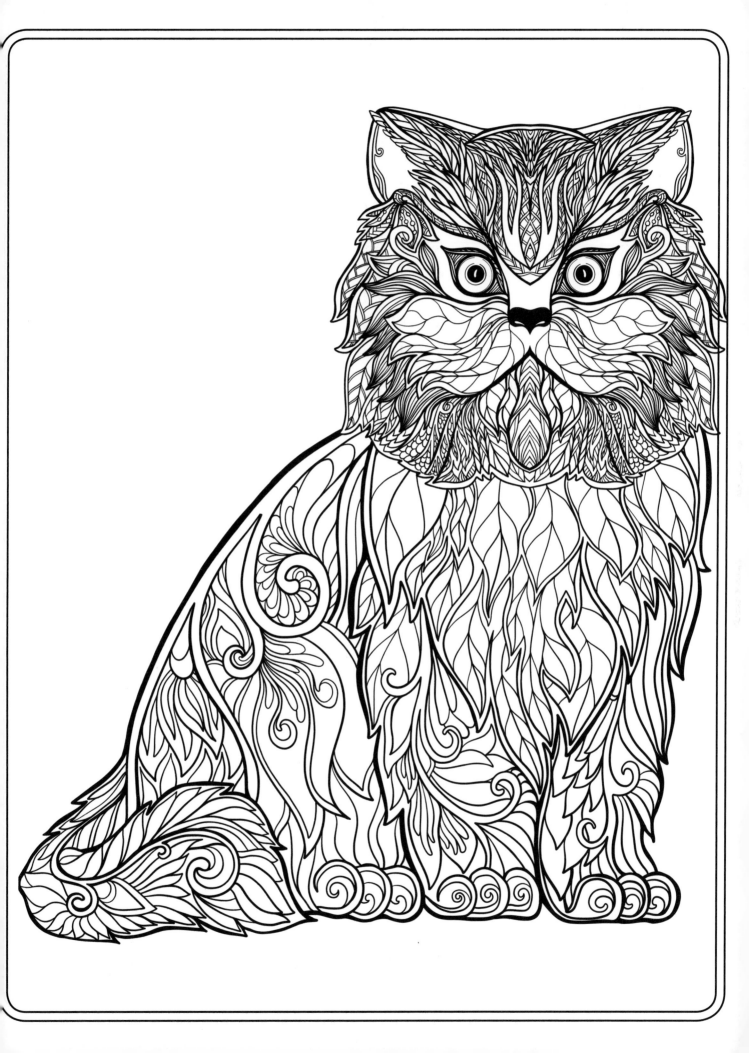

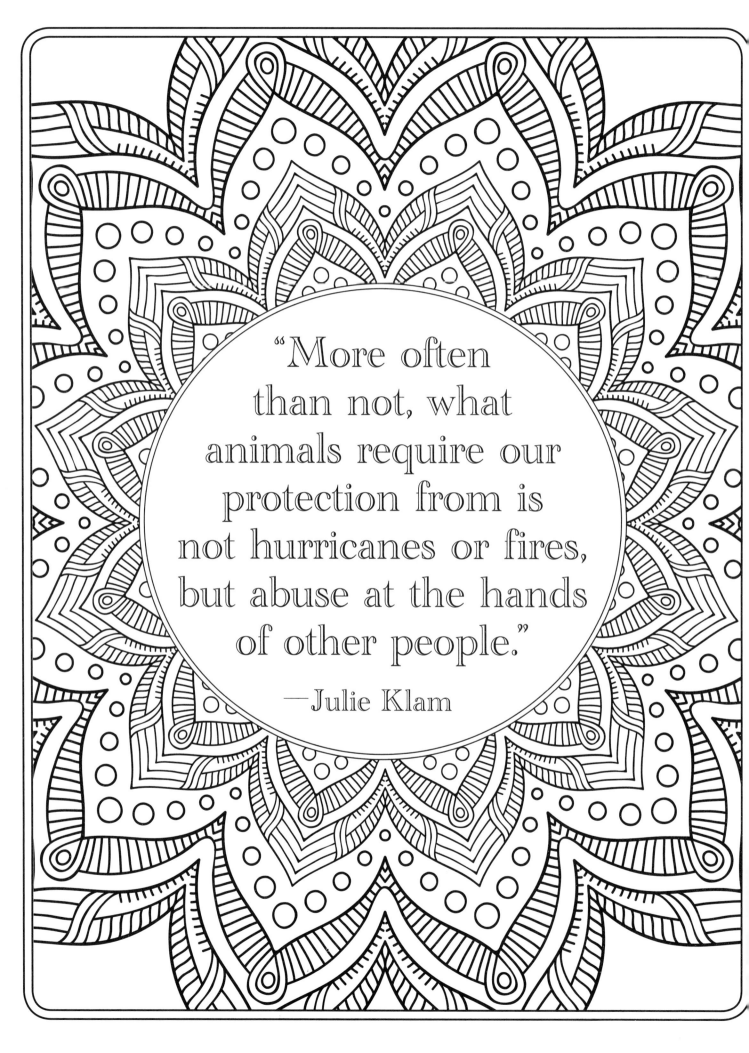

"More often than not, what animals require our protection from is not hurricanes or fires, but abuse at the hands of other people."

—Julie Klam

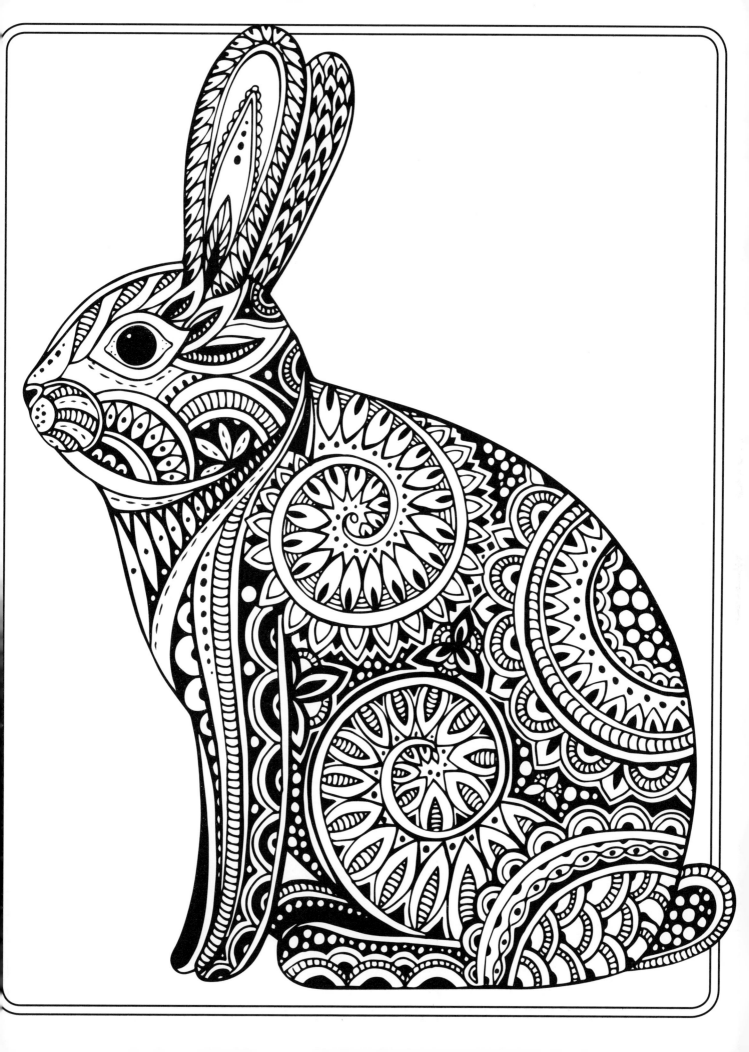

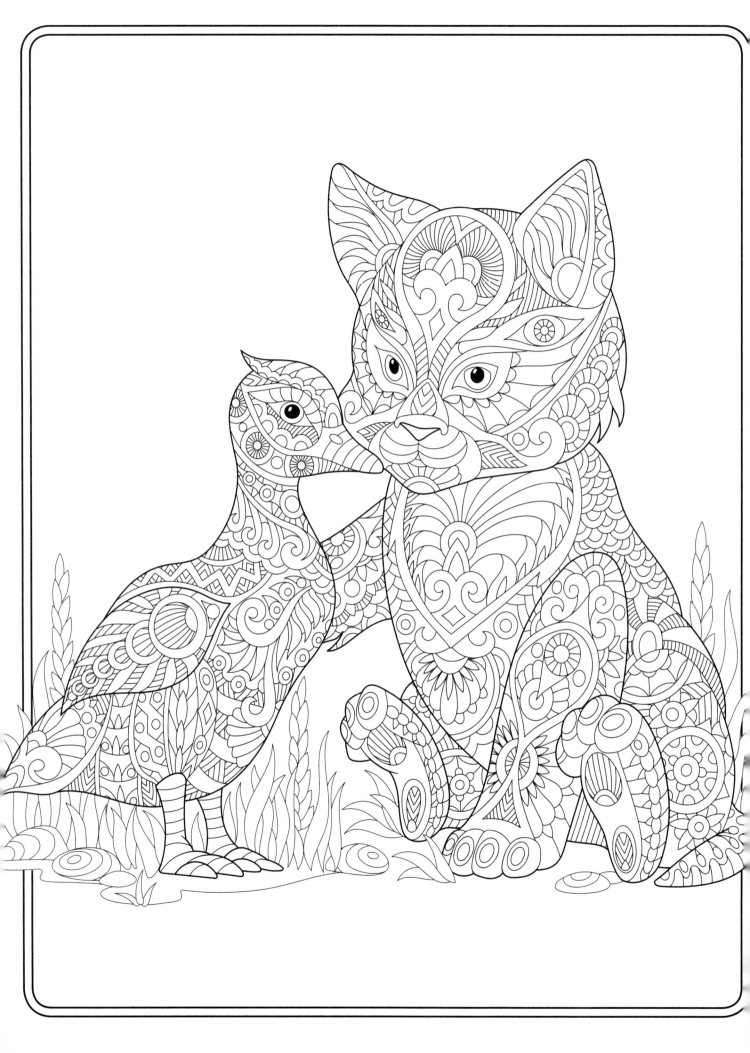

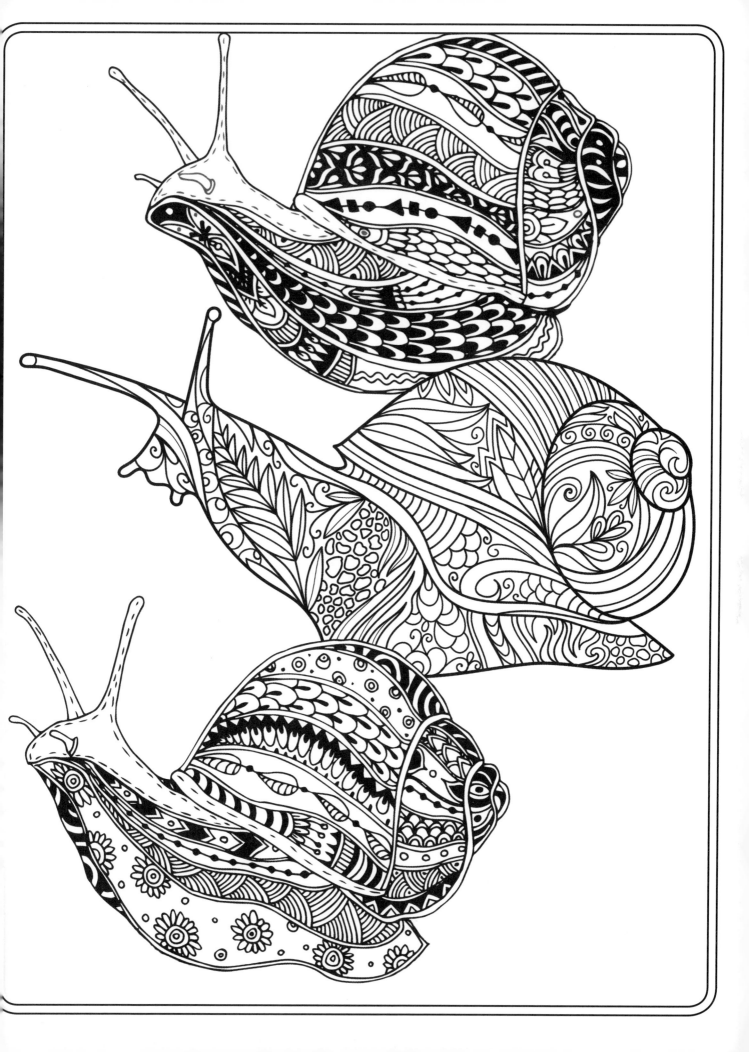

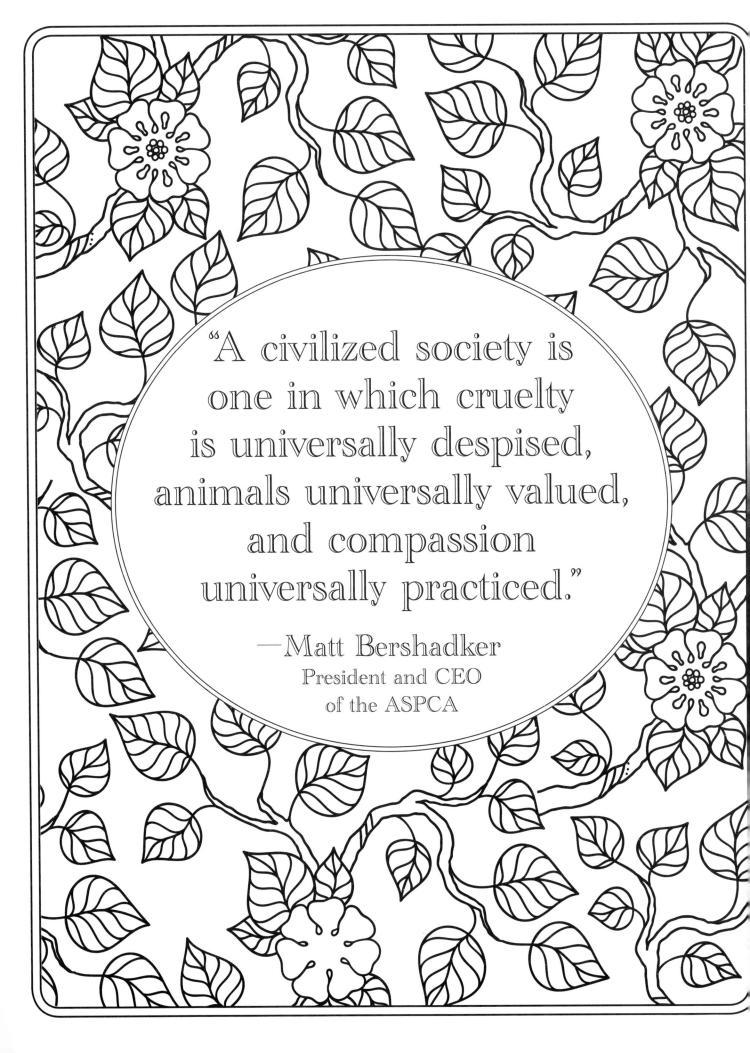

"A civilized society is one in which cruelty is universally despised, animals universally valued, and compassion universally practiced."

—Matt Bershadker
President and CEO
of the ASPCA

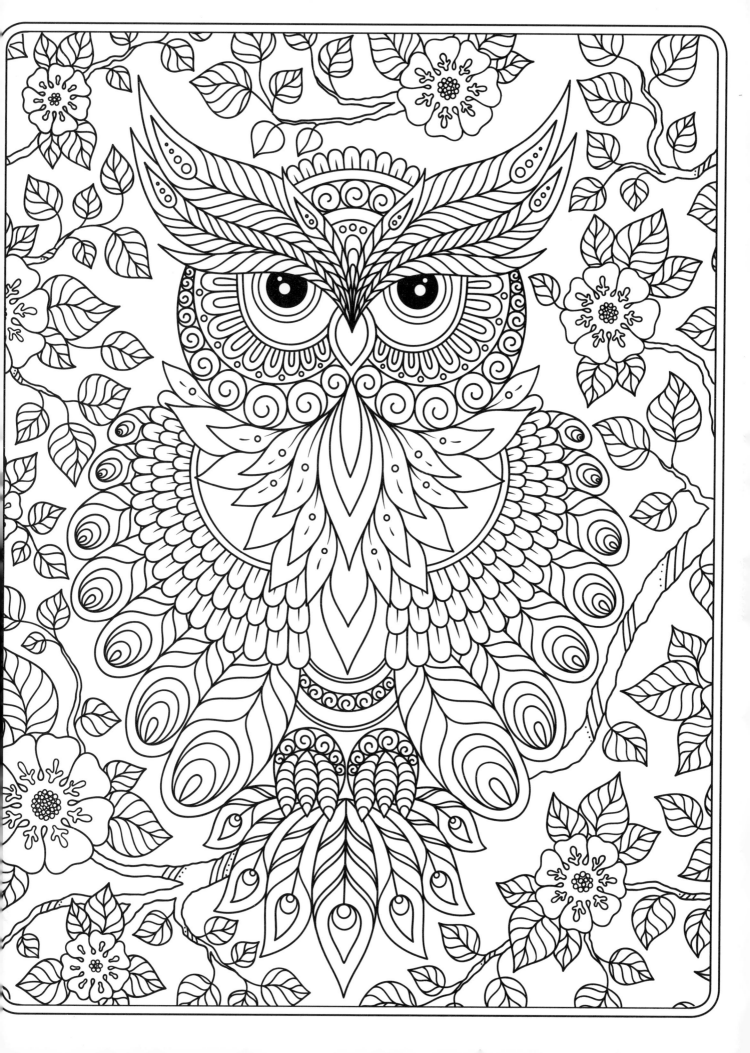

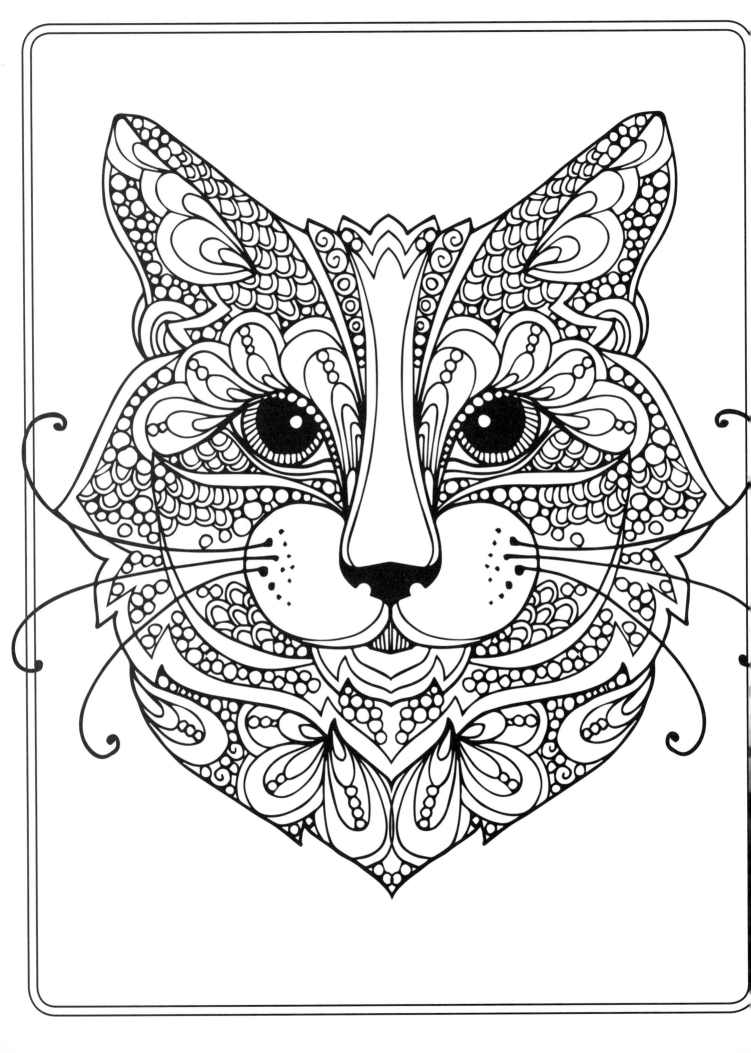

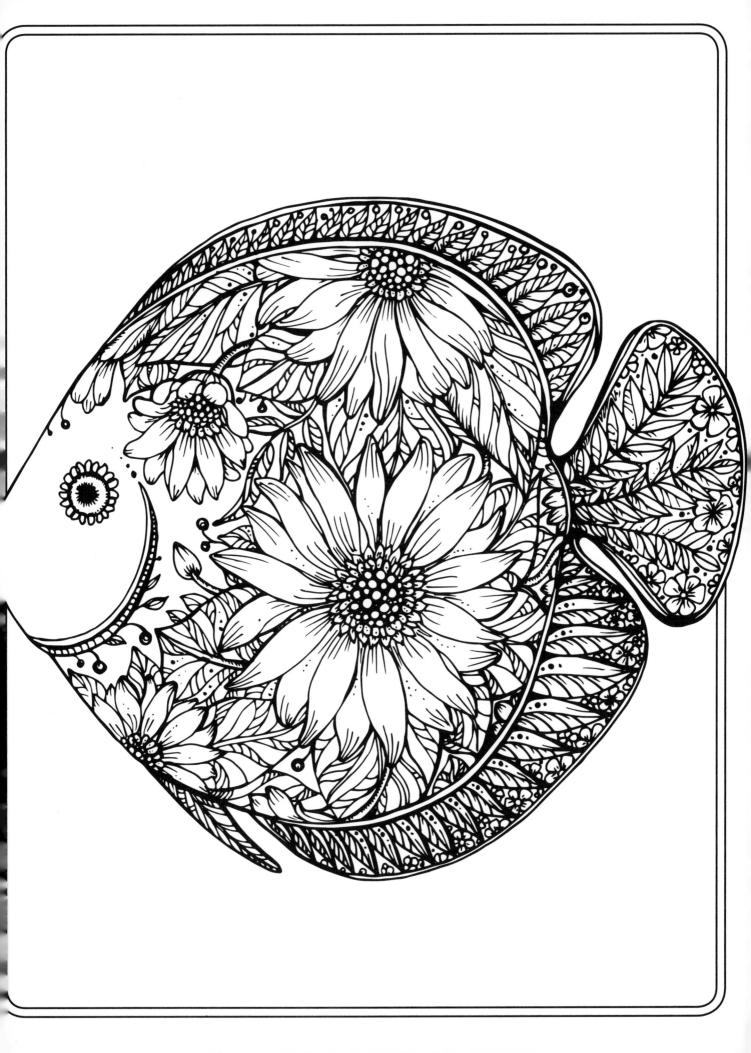

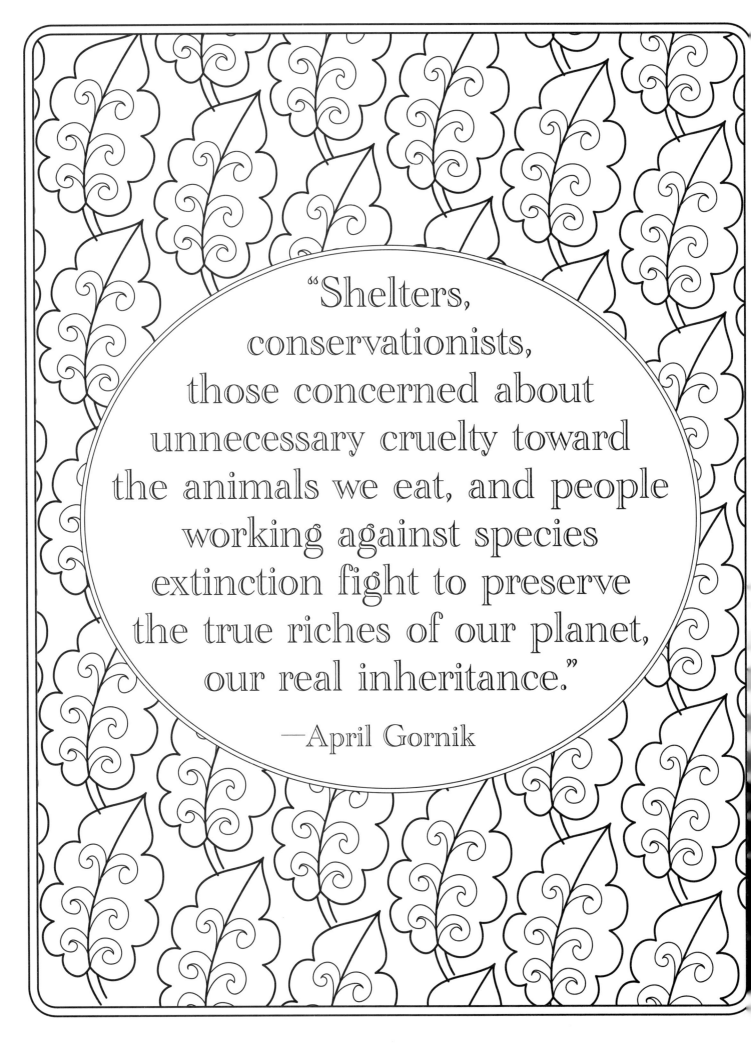

"Shelters,
conservationists,
those concerned about
unnecessary cruelty toward
the animals we eat, and people
working against species
extinction fight to preserve
the true riches of our planet,
our real inheritance."

—April Gornik

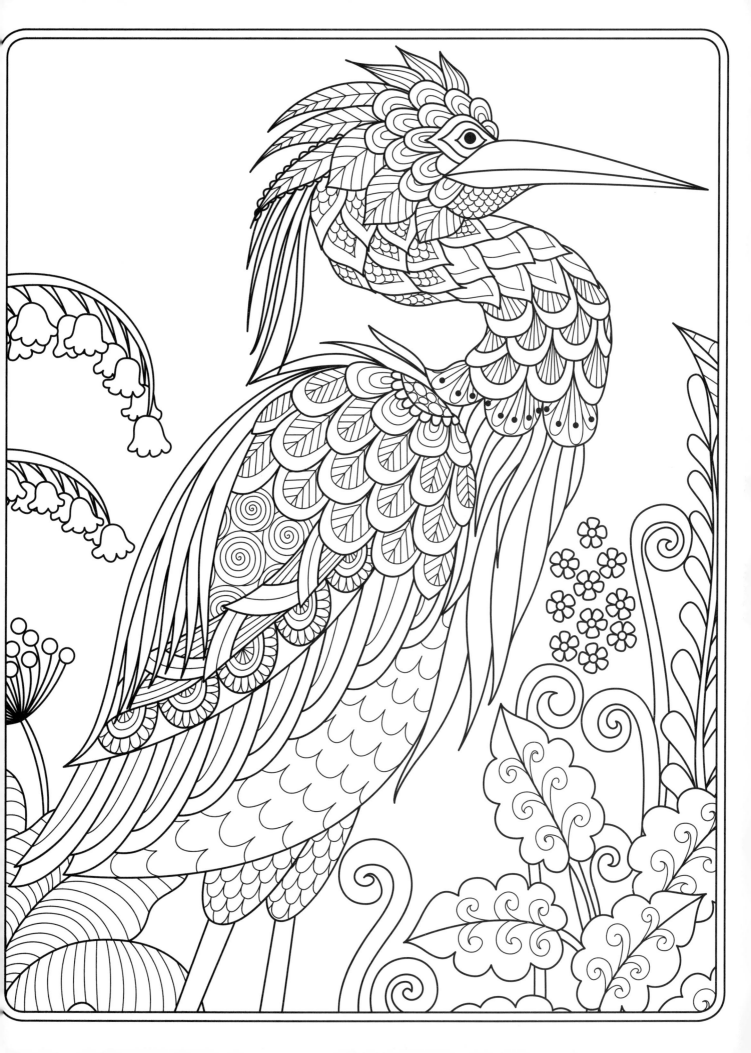

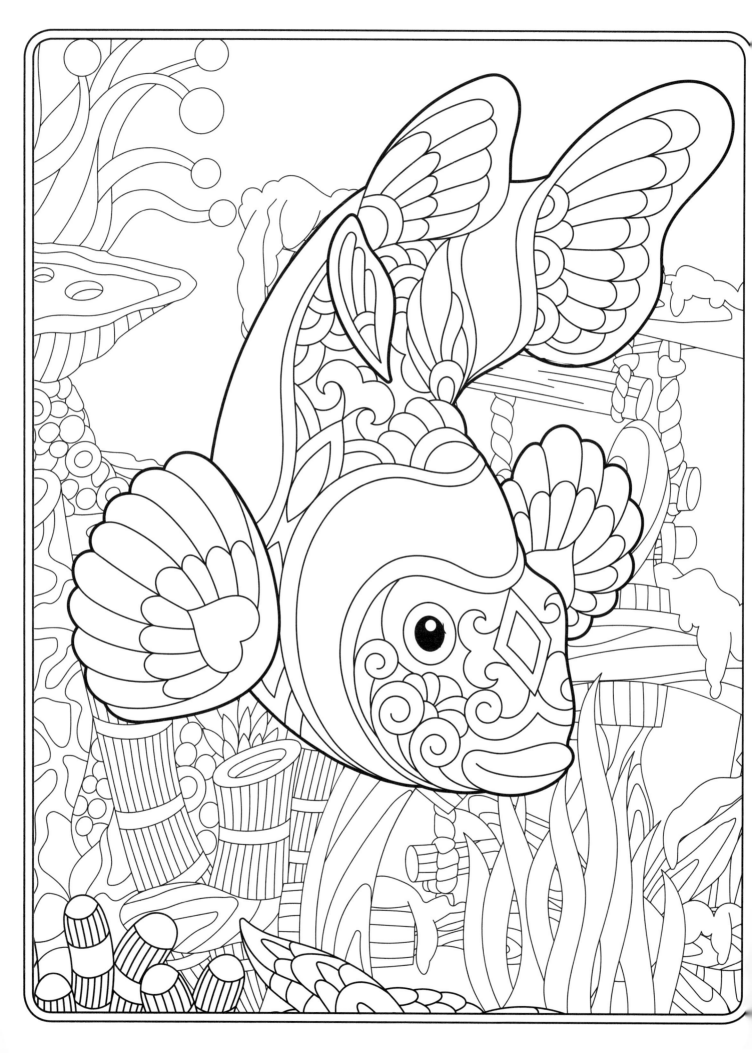

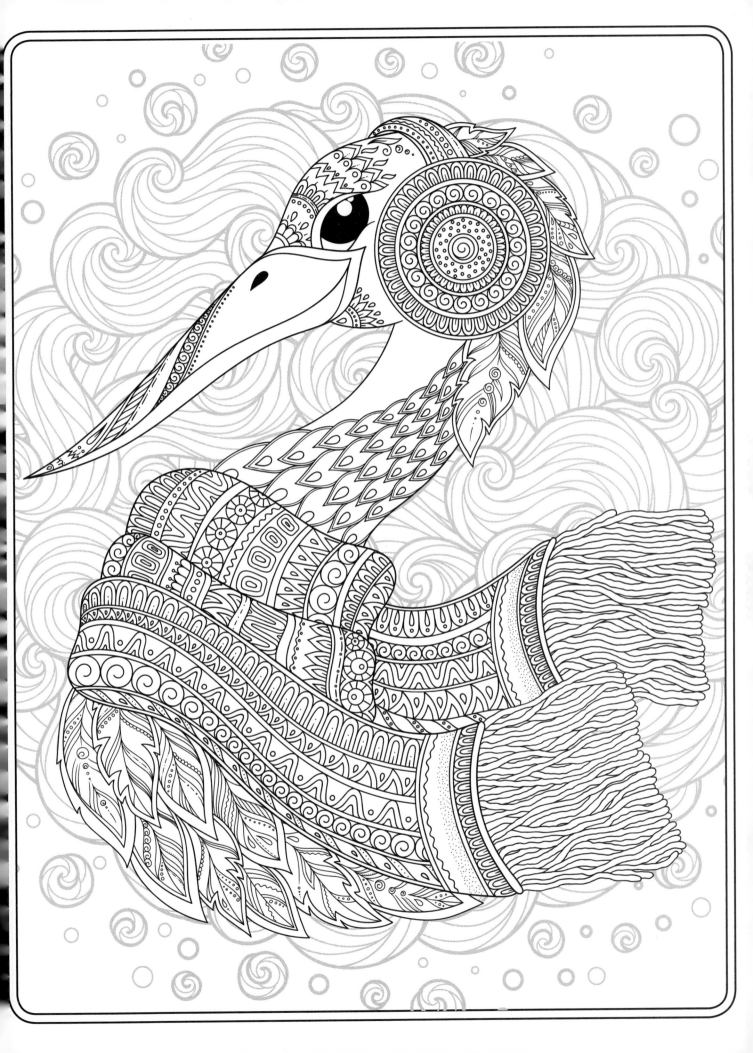

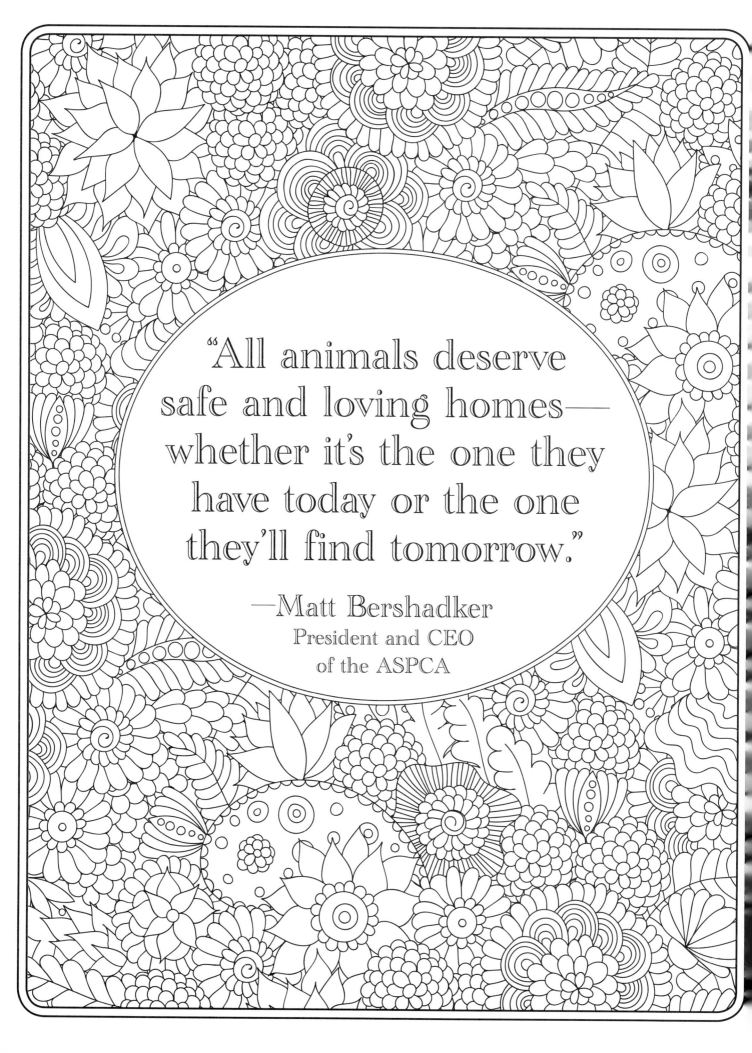

"All animals deserve safe and loving homes— whether it's the one they have today or the one they'll find tomorrow."

—Matt Bershadker
President and CEO
of the ASPCA

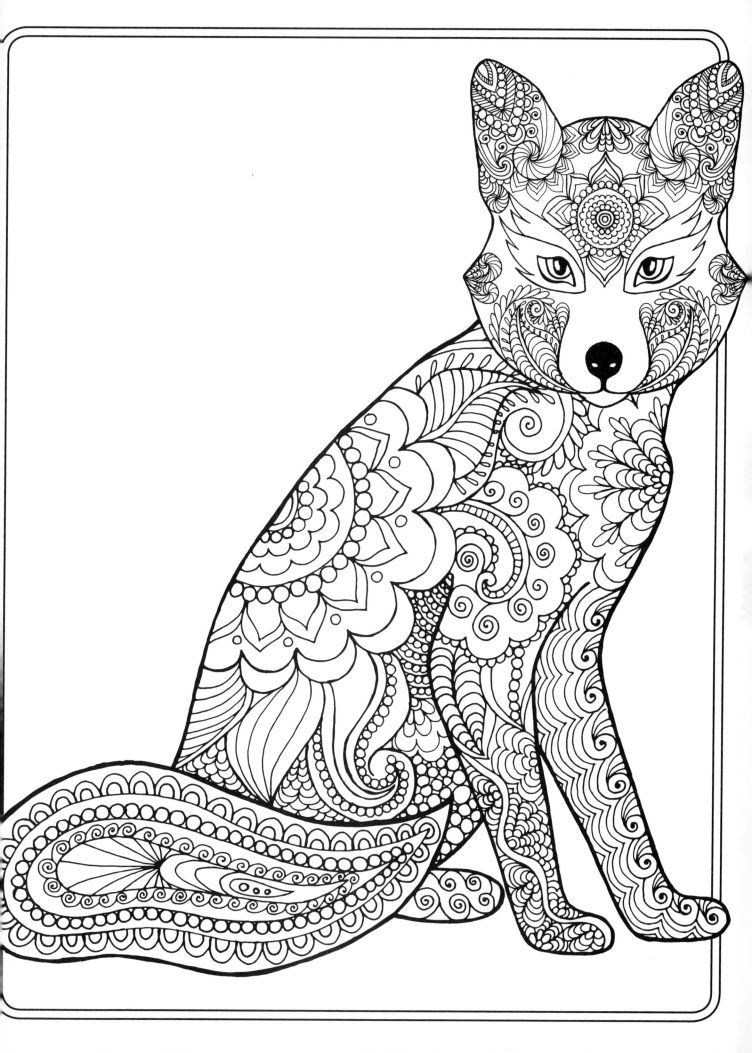

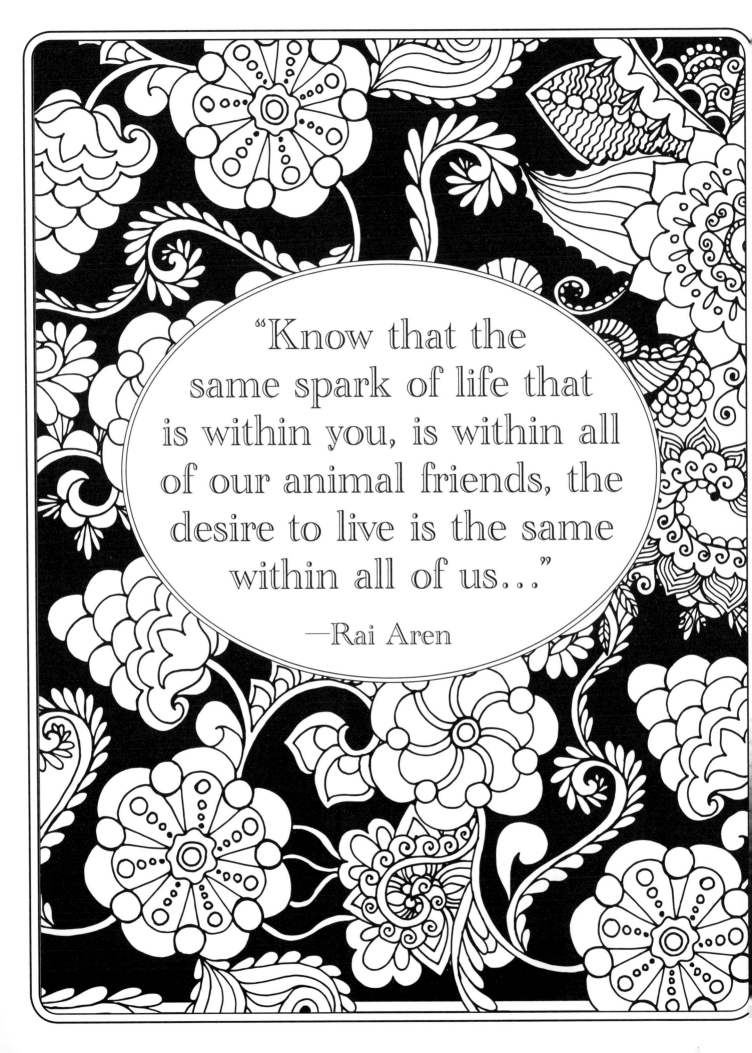

"Know that the same spark of life that is within you, is within all of our animal friends, the desire to live is the same within all of us..."

—Rai Aren

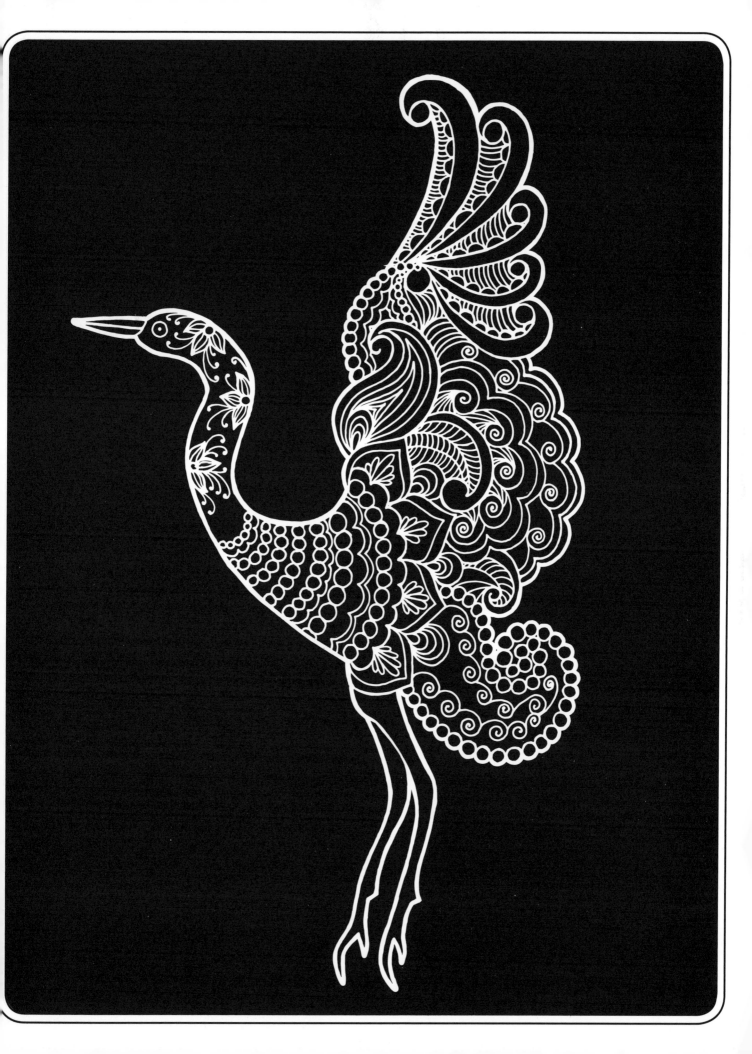

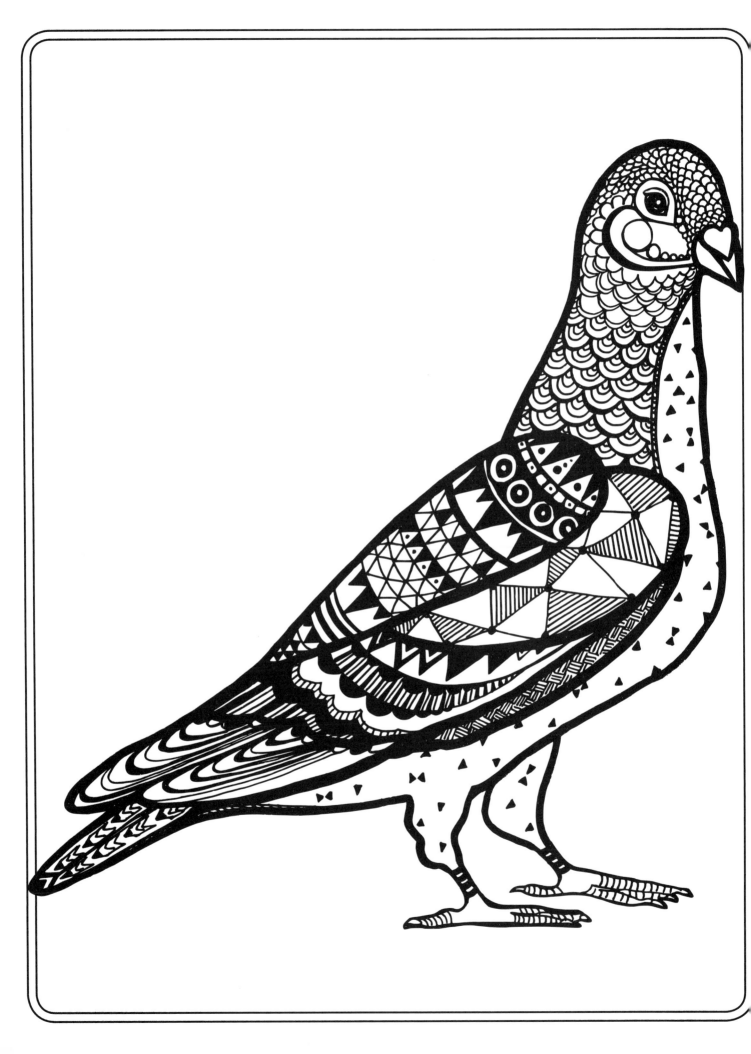

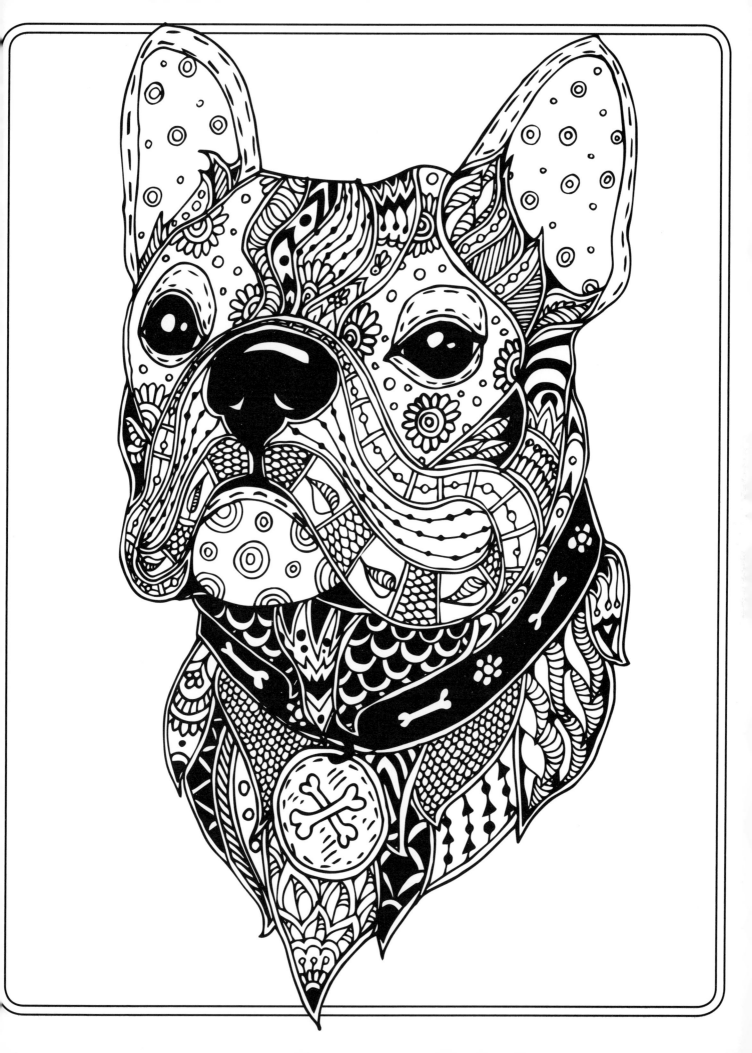

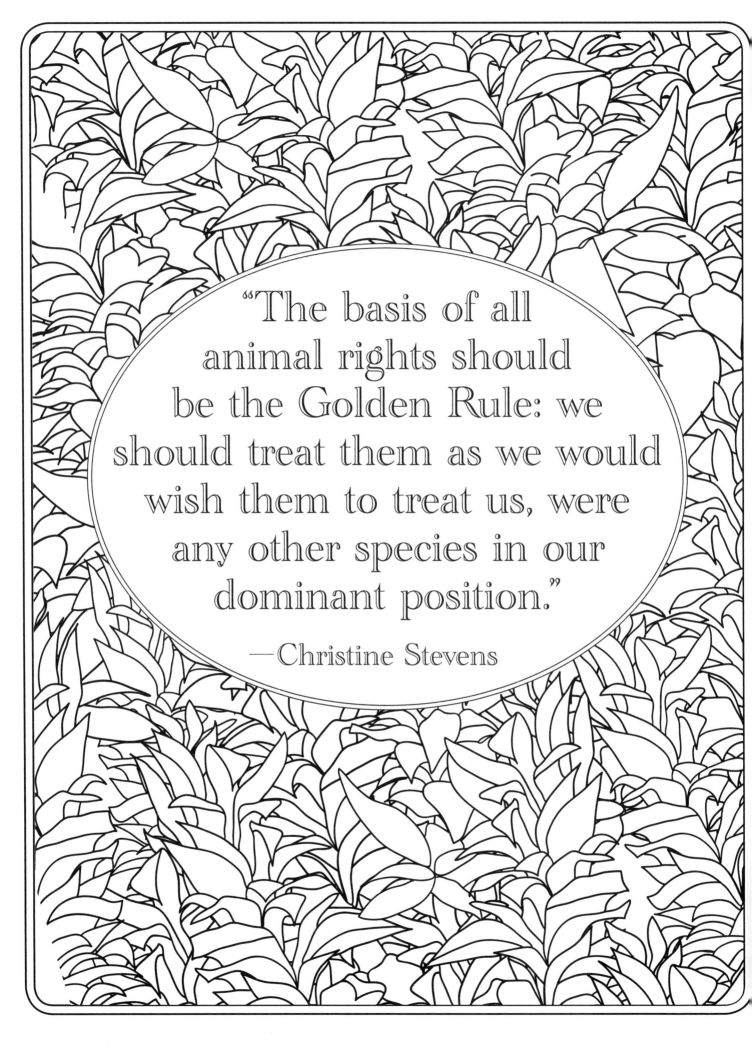

"The basis of all animal rights should be the Golden Rule: we should treat them as we would wish them to treat us, were any other species in our dominant position."

—Christine Stevens

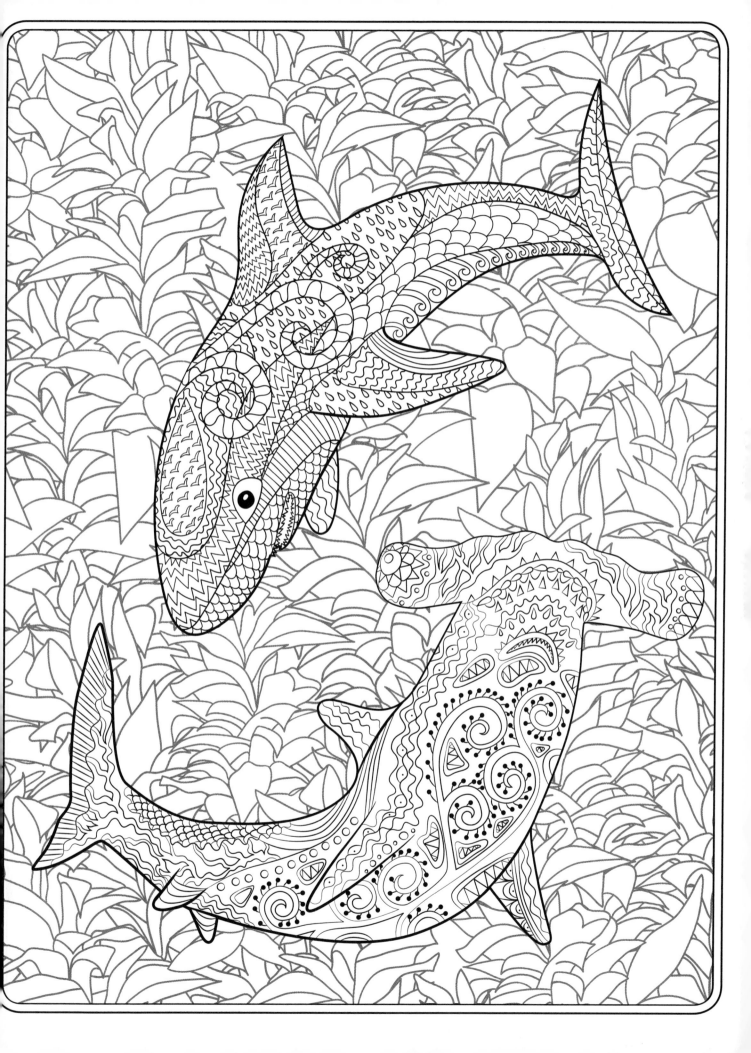

Studio Fun International
An imprint of Printers Row Publishing Group
10350 Barnes Canyon Road, Suite 100, San Diego, CA 92121
www.studiofun.com